A Few Responses to Thoughts - Sweet and Sour

A Few Responses to Thoughts - Sweet and Sour

Sanjeev Kumar

PARTRIDGE

Because of the dynamic nature of the Internet, any web addresses or links contained in this book may have changed since publication and may no longer be valid. The views expressed in this work are solely those of the author and do not necessarily reflect the views of the publisher, and the publisher hereby disclaims any responsibility for them.

Print information available on the last page.

To order additional copies of this book, contact
Partridge India
000 800 10062 62
orders.india@partridgepublishing.com

www.partridgepublishing.com/india

DEDICATED

TO

BHABHI (MY MOM)

PREFACE

Words fail to express my gratitude to all who read my thoughts and to Partridge, (A Penguin Random House Company) that brought out the two volumes of Thoughts-Sweet and Sour and ultimately got a 'non-serious' to be taken 'serious by all, one day.' The book in hand would not have seen the light of the day, had there not been continuous moral support of my senior colleague Dr. Manju Ailawadhi and blessings of my teachers, with particular mention to Prof. B.D Sharma, Prof. T.R Sharma, Prof. Jasbir Jain, Prof. Sisir Kumar Das, Prof. Jayanti Chattopadhyay and Prof. Sushil Kumar Sharma. My special thanks are also due to the other contributors— Vasant. K. Sharma, Sh. D S Tyagi, Sh. S.S. Tiwari, R.K. Chadha, Rakesh Ji, Ms. Tripti, Ms. Kavita, Dr. Manju Ji and Dr. C.S.

Dubey— had they not continuously kept giving their valuable responses to the thoughts, the present anthology would have remained only 'a dream.' I once again thank all who directly or indirectly contributed in bringing out this book. Towards the last, the most important person on the fiesta: my Bhabhi (mom), whom I miss even today despite forty years of her leaving me alone. Therefore, the publication in the hand is dedicated for her gracious blessings. I hope she will be proud to see that not only do I live in her absence but continue to read/also study— the only complaint she had when I was a child.

Sanjeev Kumar

CONTRIBUTORS

1 Manju Ailawadhi is presently working as an Associate Professor in the Dept. of English at Dr. Bhim Rao Ambedkar College(Delhi University).

2. Dr. Chandra Shekhar Dubey is also working as an Associate Professor in the Dept. of English, Bhagat Singh College(E), University of Delhi.

3. Sh. Vasant. K. Sharma is now retired and he too, was an Associate Professor in the Dept. of English, Delhi College of Arts and Commerce,(Delhi University).

4. Sh. Shyam Sunder Tiwari is at Managing Director at Advanced Sensor Research Organization (ASRO) working as Managing Director (MD).

5. Sh. Rakesh Tyagi is the Chairman, Mother India group of Senior Secondary Schools, Ghaziabad (U.P.),India.

6. Sh. Deshraj Tyagi is retired Professor from the Dept. of Geography, D.S. College, Shamli(Meerut University).

7. Ms. Tripti is presently an Assistant Professor in the Dept. of English at Dr. Bhim Rao Ambedkar College(Delhi University).

8. Ms. Kavita is a post graduate in Business
 Administration from Uttrakhand Technical University,
 Haridwar(U.P) India.

9. Sh. R. K. Chadha is now retired after having
 served for more than four decades as an Associate
 Professor in Aryabhatt Polytechnic Institute,Delhi.

1. NOT 'ALL' ARE CURSED TO RELISH THE BLESSINGS.

Manju Ailawadhi: *What they see as 'blessings' may actually be a 'curse' is it?*

Author Kumar: *Maybe this can be an angle too, from where things may appear differently altogether.*

2. IT JUST CANNOT BE CALLED 'PARENTAL LOVE' IF EITHER OF THE PARENT SAFEGUARD THE CONCOMITANT, IRRESPECTIVE OF WHAT HE DOES.

Manju Ailawadhi: *But in today's world it is called 'unconditional' love. Some old- School may not agree, but in the present times, they shield every doing*

1

of the progeny not bearing that this is detrimental to the health of society,

Author Kumar: *GOD forbid for they do not know what they do.*

3. HUMAN RELATIONSHIPS MAKE YOU WISER AND WORLDLY.

Manju Ailawadhi: *That is what precisely what human relations are for, other than showering love and affection!*

Author Kumar: *undoubtedly.*

4. LIFE IS AN EXAM. PASS IT THROUGH FAIR MEANS; THERE MAY NOT BE A SECOND CHANCE IF BOOKED FOR "UFM".

Manju Ailawadhi: *Most of the ills of life would vanish into nothingness if all*

took 'being fair' as a mission.

Shyam Sunder Tiwari: *There is nothing that humans can produce other than taking from nature, and that happens to be a share of many but is made by all unfair-means only by few. To survive here, do whatever it takes as that is the first thing to do before anything else can be done.*

5. IT IS ONLY VERY LATE ONE REALIZE THAT IT WAS ONLY HE WHO RAN LOOKING FOR LOVE AND AFFECTION ALL AROUND AND NOT ANYONE ELSE FOR HIM.

Manju Ailawadhi: *Yes that is the bitter truth that at times one doesn't get*

love and affection from expected quarters, but then the sun shines on our souls and that light comes from some other unexpected quarter.

Author Kumar: *Quite an optimistic perspective.*

6. 'RELATIONSHIP' IS BOUND TO SEIZE THE MOMENT ONWARDS; ONE CONCLUDES THAT THE PRIMARY INGREDIENT 'UNDERSTANDING' WAS ONE WAY, AND THAT WAS MISSING THROUGHOUT.

Manju Ailawadhi: *Basic understanding / comprehension/compatibility is the foundation stone of any relationship, especially if one thinks of it as a long*

4

term proposition. Suns opinion it
peters out eventually.

7. 'LOVE' AND AFFECTION THAT COME WITHOUT HAVING EVER ASKED FOR, COULD BE A 'MIRAGE.'

Manju Ailawadhi: *Love and affection come naturally or instinctively; they do not need any outside force to be generated.*

Rakesh Tyagi: *I think love & affection are temporary feelings like bubble & mirage. They come and go after a short time.*

Tripti Tyagi: *Seemingly when maggie*

tulliver fell in love in <u>Mill on the Floss</u> is the best exemplar

Kavita Tyagi: *Yes right enough.*

8. "TONE" SPEAKS ALL.

Author Kumar: *Yes, honestly said for the 'tone' carry all undertones.*

Manju Ailawadhi: *Yes it is the intonation of the tone that matters, for it adds a gloss to unpleasant sayings too.*

Rakesh Tyagi: *Yes Tone is expressive of one's feelings. One can guess in your heart and mind by your tone itself.*

TriptiTyagi: *Indeed sir. Such paralanguage has camouflaged parellels of one's speech.*

9. A 'WORKSHIRKER' IS CAPABLE ENOUGH TO DISCOLOUR "ALL".

Manju Ailawadhi: *I think the 'work shirker' has an inherent capability to slip sideways from work and then also have the audacity to paint the difficult ones as doing an ineffective/valueless job.*

10.'BLESSED' CAN ONLY BE WHO SECURE AT LEAST HIS 'ANCESTRAL SHED,' FOR IT PROVES TO BE THE ONLY PLACE AND HEAVEN ON EARTH ESPECIALLY AFTER HE UNDERSTANDS 'THE WAYS OF THE WORLD AROUND.'

Manju Ailawadhi: *Blessed are they who got an old shed, and more so if they were able to keep it as a treasure!*

Author Kumar: *Very true.*

Rakesh Tyagi: *I agree with you sir*

Author Kumar: *Thank you, Rakesh ji.*

11. SAD ENOUGH WHEN ALL "EYE" ON THE 'SHARE' THAT DOES NOT BELONG TO THEM BUT WHICH MAY POUR IN, PROVIDED THEY PLAY 'SAFE'.

Manju Ailawadhi: *The share is 'eyed' when either one is incapable, or one doubts the intention of the giver. Both are unpalatable situations.*

Author Kumar: *Undoubtedly.*

12. NOT ALL CARRY THE EXPERTISE TO HIDE WHAT IS BEING COOKED IN THEIR MIND.

Manju Ailawadhi: *Some straightforward lead lives which do not harbour any space for concealment/ hiding anything from the public eye, for their very life spells innocence and transparency.*

Tripti Tyagi *However in the postmodernist age, it is required to sustain. After all it's the world of simulacra.*

Rakesh Tyagi: *Yes, everyone cannot be secretive, but if one is than you cannot come to know what he is planning to do.*

Kavita Tyagi: *"APPEARANCES CAN BE DECEPTIVE" as William Shakespeare had said.*

13. TO HIDE WHAT YOU CONCEAL AT HEART IS AN "ART."

Manju Ailawadhi: *And some are past masters at the art of concealing and thereby succeed in deluding the simple one.*

Author Kumar: *Yes, but unfortunately not for very long.*

14. THE 'GAPS' THEMSELVES CAN BE FILLED UP TO MAKE THE SENTENCE COMPLETE.

Manju Ailawadhi: *Yes provided one is alert enough.*

15. ONLY A 'BLACK HAT' CAN STOOP TO THE POINT UNBELIEVABLY THAT PUTS EVEN ITS LOOKALIKE AT STAKE AND ALSO DIVERT 'ALL' FROM THE MAIN 'AGENDA'.

Manju Ailawadhi: *Those that wishes to be fooled is eventually tricked, for they do it with an ulterior motive.*

16. ONLY "DEVILS" TAKE PLEASURE DECISIVELY IN TAKING THE HAPPINESS FROM THE WORLD AROUND.

Shyam Sunder Tiwari: *That is the definition of a Devil.*

Kavita Tyagi: *Not exactly for 'good' in disguise too, is there.*

17. OFTEN THE "YOUNG" PRETEND TO BE "LEARNED AS WELL AS MATURE" WHEREAS, THE "OLD" DO THE OPPOSITE.

Manju Ailawadhi: *Only those young put on the garb of maturity, who themselves doubt their own credibility and seem to be in just haste to be proclaimed 'learned.'*

18. A GANG LEADER MAY RELISH THE 'AESTHETIC PLEASURE' BUT THE ACTUAL POWER IS ENJOYED BY THOSE WHO STAND BY HIM.

Manju Ailawadhi: *That is called enjoying the perks of waiting in the wings after sacrificing self-esteem!*

19. 'EVIL SPIRITS" OFTEN COME IN A THRONG FOR NONE IS SELF ASSURED TO DEFEAT THE 'RIGHT' IN AN INDIVIDUAL CAPACITY.

Manju Ailawadhi: *Despite all odds against the 'individual' good, history bears*

testimony that good is always lesser in numbers but despite that vanquishes the 'throng' of evil.

Author Kumar: *very rightly said, Mam.*

20. EACH OF "EVIL'S" PET WORKS WITH AN UNIMAGINABLE DEDICATION FOR THE MASTER IN THE HOPE TO RELISH TEMPORARILY, AT LEAST A FEW OF ITS ATTACHED POWERS SIMULTANEOUSLY.

Manju Ailawadhi: *For they are grateful for whichever crumbs that are thrown at them, taking them to be no less than 'manna' from Heaven itself! Let such wallow in their own deceptive beliefs!!*

21. A GOLD BRICK CARRIES DUBIOUS CREDENTIALS.

Manju Ailawadhi: *Yes and especially if done in a short span.*

22. THE ONLY WORD OFTEN MISINTERPRETED/MISUSED IS 'HARASS' FOR NO WORD- BOOK TALKS OF ITS MEANING AS 'BLACKMAIL OTHERS.'

Manju Ailawadhi: *In the present times people have become so accustomed to work shirking that arm twisting tactics and maligning innocent doesn't even merit a second thought before plunging in the mire. But what one sows so one reaps.*

Author Kumar: *Undoubtedly, pages in the Chronicles have underlined it more often.*

23. 'EVIL' LIVE LONG FOR THE SWORD OF DEMOCLES DEMAND OF IT.

Shyam Sunder Tiwari: *Evil is like a dirty water which is available easily and won't vanish. It is hard to get clean water, and one has to clean the dirt to get it. Evil exists and good is born out of it by refining.*

24. IT IS THE 'DAY' THAT TAKES "SOME" OUT EVERY DAY FOR THEY ARE NOT ALLOWED TO CARRY IT WITH THEM.

Manju Ailawadhi: *The undeniable reality is that all mortals come empty handed and also depart empty handed, despite whatever material wealth they may have amassed in their short or long tenure in this world!*

25. THE WEIGHT A 'PAPER' CARRIES MAY BE VERY LIGHT, BUT IT PROVES TO BE THE 'HEAVIEST OF ALL', ONE DAY.

Manju Ailawadhi: *The weight I suppose is due to the 'leaden' word put on it.*

26. ONLY A 'MISCREANT' CAN BOAST OF THE EXPERTISE IN THE ART THAT CONVINCES OTHERS WITHOUT ANY 'PAPERS' IN SUPPORT OF HIS CLAIM, BUT THE FACT IS BEYOND DOUBT THAT HE SUCCEEDS JUST BECAUSE NOBODY WANTS TO BE HIS NEXT TARGET.

Manju Ailawadhi: *For eventually it is a skin- saving exercise that people are excelling at!*

27. THE 'MAJORITY' IS COMPRISED OF THE PEOPLE WHO DO NOT 'HELP' BUT SAVE THEIR SOULS INSTEAD, UNDER THE GARB.

Manju Ailawadhi: *Yes, quite right. Most of the times people like to send out wrong signals posing as helpers wherein the truth is that their only intension is to save their own skin.*

28. IF AT ALL AN ORDINARY MAN FIGHTS, HE DOES SO NOT TO DEFEAT BUT TO DEFEND HIM.

Manju Ailawadhi: *Simply because he needs to protect himself rather than gloat in the mire as others do.*

Rakesh Tyagi: *Sir is very real and practical. The ordinary man fights for his survival.*

Tripti Tyagi: *Very nice quote sir.*

29. THERE CAN ONLY BE TWO POSSIBILITIES, EITHER THE 'OTHER' PERSON HAS DIALED THE WRONG NUMBER OR YOU ARE DIALING IT NOW.

Manju Ailawadhi: *Whatever the case may be, one cannot be hopeful of getting the desired response from a 'wrong number.'*

30. IT IS THE 'MARGINAL' EXTRA EFFORT THAT THE WINNER PUTS IN FOR BOTH THE TWO CONTESTANTS CARRIED 50 PERCENT PROBABILITY EACH WHEN THE "RACE" STARTED.

Manju Ailawadhi: *What is termed 'marginal' is actually the only*

concerted/sincere effort that was ever required to win the race, and definitely not rest till the 'finish' is reached.

Author Kumar: Maybe you are right.

31. IT IS ONLY AFTER HAVING UNDERGONE THE MOST TRAUMATIC PHASE THAT THE TIME TO COME AHEAD BECOMES 'CRYSTAL CLEAR'.

Manju Ailawadhi: However is trying, torturous or haranguing the times, things do change. That is the way of nature. Darkness cannot hang forever; it will be dispelled.

Author Kumar: *Yes, very true for darkest is the night when 'dawn' is at hand.*

32. 'LOVE' THAT CREEPS INTO THE HEART AND SEEKS DUE PERMISSION TO ENTER, SIMPLY CAN NEVER BE 'TRUE.'

Manju Ailawadhi: *Love happens of its own; it needs no authorization to enter a heart. If permission is sought then it is a difficult exercise, and that is not true love, it could be an arrangement of convenience that is hidden under a garb falsely termed love.*

33. NOT 'ALL' WHO HAD OUTLIVED TIMES OF PENURY; RELISH THE MOMENTS OF 'PROSPERITY'.

Manju Ailawadhi: *For one never knows how the equations have changed on this journey.*

Author Kumar: *True enough.*

Shyam Sunder Tiwari: *It is good to learn about poverty than anything about rich life.*

34. A NAME THAT COMES WITH 'ANCESTRY' OFTEN FADES INTO OBLIVION, ONLY BECAUSE NO SUBSEQUENT GENERATIONS OVER TOILED TO RETAIN THE SAME.

Manju Ailawadhi: *Yes, a worthy*

predecessor, definitely deserves an equally brilliant progeny, but if they develop a lackadaisical attitude to life, then the predecessor also goes into oblivion except for retaining some space in some dear one's memory.

Author Kumar: *very correct.*

Shyam Sunder Tiwari: *Gandhi of all kinds we see now is an excellent example. Initial progeny perhaps for humans started with God and Goddess and may end up in Devils and monsters. It*

is undergoing all kinds of iterations of greatest diversity. It is perhaps acknowledge of all sorts finally.

35. THE STAY OVER HERE IS SIMILAR TO AN 'INN' WITH THE ONLY DIFFERENCE THAT WE DO NOT REMEMBER OUR LAST STAY.

Shyam Sunder Tiwari: *Being in "inn" is being in other's charity. Creating an "inn" and being a charity is much better. I do like such great thing and do remember the inn I stayed in 50 years ago when I was a child and was discovering a very new place with little pocket money.*

24

Manju Ailawadhi: *Our stay here is transient, we are entirely ignorant of the fact when our exit may happen. Therefore, it becomes imperative for us to make our stay worth the while, for once gone only memories of the good done will be our tribute.*

Shyam Sunder Tiwari: *This I was thinking yesterday. Do we carry the knowledge of being here and the pain of this world with us? Then it will be miserable as we will not even be having the body to make changes*

and just abstract knowledge of this life. Perhaps we will have nothing of this life as we have none of the past lives.

36. DEMARCATION TO ENCASH 'MORAL' BUILDINGS' SHOULD BE WELL DEFINED.

Shyam Sunder Tiwari: *Moral binding is not a check of some value that one can en-cash. However, it does a spell of responsibility such as care for old parents by children.*

Manju Ailawadhi: *Moral binding of necessity entails that a person's morality is intact, and then there are*

really no issues. All these problems arise when people either do not have any morality or choose to look askance when challenged with a difficult situation and prefer to ride with the tide.

Shyam Sunder Tiwari: *Moral is associated with every duty, but it is flawed everywhere. Worst of them are the judges who are supposed to judge other are moral values without having any of their own.*

37. AN EQUAL AND OPPOSITE REACTION IS VALID ONLY IN THE 'CHEMICAL COMPOSITION' AND NOT TO HUMAN EQUATIONS.

Manju Ailawadhi: *In human equations the equal and opposite reaction cannot be the same because every human's perception/ reaction cannot of necessity be in the same ratio for it has a personal angle of understanding, sensitivity, emotion and current attitude of the people involved.*

38. THE ADJECTIVES, LOVING, AND CARING, OFTEN ONLY DESCRIBE THE NOUN, 'PARENTS'.

Shyam Sunder Tiwari: *Without parents no real existence of the self.*

Author Kumar: *But unfortunately, some think their 'existence' would have been better had they were born to different parents?*

Author Kumar: *Very rightly said, but some realize it the time they had lost them.*

Manju Ailawadhi: *No matter what offspring's think, the fact remains that only parent's love n care for their children n that took to the point of*

distraction. And this truth dawns on some when they step into the shoes of parents. And each gets what is destined for him.

Author Kumar: *Yes I agree.*

39. IT IS THE 'INTENT' THAT WILL HAVE THE 'FINAL SAY'.

Shyam Sunder Tiwari: *It is the action which produces results, as intent is only an attitude.*

Author Kumar: *Well, I believe it is the intention that comes first and the 'work' later.*

Manju Ailawadhi: *Only a good, honest and positive intention can propel one on the path that ultimately leads to real satisfaction, for without 'intent' no action is possible.*

Author Kumar: *Very well said, Mam.*

Shyam Sunder Tiwari: *Many things do happen in life just accidentally. The entire emergence of sciences and its subsequent development is very much accidental in these 100 years. Even the life on earth is unexpected. Circumstances play a role and do*

become stronger than intent in life. However, the role of intent is worth as that something one becomes responsible for eventually willfully.

40. REAL 'WARMTH NEVER COOLS.

Shyam Sunder Tiwari: *One should be cool enough to remain warm in relationships for the entire life.*

Author Kumar: *Good play with words and, of course, correct enough.*

Manju Ailawadhi: *If it is genuine n real n handled with nimble fingers its warmth remains intact n is a*

perennial source of happiness.

41. THE 'CONTENT' IS UNMATCHABLE WHEN ONE HAS NOTHING TO LOSE.

Shyam Sunder Tiwari: *A loser will always lose something even when there is nothing to lose else will not remain a loser by definition.*

Author Kumar: *It is not about the 'loser' but the winner who relish ultimate 'satisfaction' of never to lose, simply because he never had anything to put at stake.*

Shyam Sunder Tiwari: *One's prestige is*

always at stake and liberty is only till one remains within the limits of dignity. Ultimate freedom isn't for anyone even in the assumed theoretical state of "nothing to lose".

Manju Ailawadhi: *It is a fearless state of mind that goes on moving ahead without any hesitation, and especially when nothing is at stake, or one has the 'couldn't care less attitude. Blessed is the one who is without any trappings and therefore feels energized to forge his way*

without a hindrance.

Shyam Sunder Tiwari: *Think of those who give their life on boarders and what is at stake for them. The human mind can set the determination in a certain way without giving too much value to the consequences. Life can have a purpose by self-confidence.*

42. COLORS DRENCH 'YOUTH' COMFORTABLY.

Manju Ailawadhi: *Yes youth has more flexibility and readily embrace color of every hue very energetically.*

43. LESS THE AMBITION TO ACCUMULATE, MORE THE DISSATISFACTION TO DISSIPATE.

Manju Ailawadhi: *Amazing! Not only the thoughts but the artistry that goes in is also captivating.*

Shyam Sunder Tiwari: *A right move makes incredible things very much possible.*

Author Kumar: *Maybe. Not very sure Dr. Shyam Sunder Ji and Dr. Manju.*

44. IT IS BETTER TO PURCHASE WITHIN THE 'OFFER PERIOD' THE SALE OF YOUR PEACE OF MIND; FOR THOSE WHO SELL IT, ALSO GIVE, AT LEAST, FEIGNED RESPECT AND SHOW OF AFFECTION AS AN EXTRA INCENTIVE TO IT.

Manju Ailawadhi: *'Peace of mind' bought*

during the 'sale period' or even at an exorbitantly high price is something to be valued, for only that can retain one's sanity in the long run.

Author Kumar: *That's true.*

Shyam Sunder Tiwari: *If you can afford to purchase peace of mind then just do it.*

Author Kumar: *Yes.*

45. SOME INHERIT THE MERIT AND THEREFORE, NO MATTER HOW YOUNG ONE MAY IS, HE IS TAKEN TO BE TOO OLD TO BE TAUGHT 'WORLDLINESS'.

Shyam Sunder Tiwari: *Some do inherit*

responsibilities of adults.

Author Kumar: *True.*

Manju Ailawadhi: *Some that have 'greatness thrust upon them' by virtue of their birth, and are well connected, spend most of their otherwise ordinary lives, under the cloud of delusion, that they enjoy a grand status in society and are also blessed with great qualities if the intellect. Whereas the fact is that it is only a mirage that lesser mortals dare not point out and therefore their*

egoistic opinion of themselves.

46. THE ONE AND ONLY PERSON WHO REMAINS UNTIL THE END IS THE FELLOW CALLED 'LONELY' SO THAT DESPITE BEING ALONE, HE CAN GIVE YOU COMPANY.

Manju Ailawadhi: *Company is what another wills to give, it may be temporary or of a lasting nature, and one cannot compel another for it, it has to be given freely, readily and without restraint.*

Author Kumar: *But the condition does not imply to the one companion mentioned above.*

47. THE BEST GIFT OF ALL BY OUR PARENTS IS THIS 'BODY' AND THE TONNES OF WISHES FOR A HAPPY JOURNEY, BUT HOW LONG EACH MANAGES TO MEASURE UPTO THEM ALSO DEPENDS ON THE SUPPORT WE GET FROM THE CIRCLES TO WHICH WE ARE ATTACHED.

Manju Ailawadhi: *Sure enough, for all humans are by-products of our circumstances. If environment/ circumstances are congenial we are propelled in the right direction but if they become unharmonious then not only does the journey become long and tedious but also gets derailed from the right course/path that had been envisaged for us.*

40

Shyam Sunder Tiwari: *Not the child birth but child care is the greatest responsibility of the parents irrespective of their financial and social status, ability or disability, religion or nationality.*

48. SOME 'DISTANCES' ONLY WIDEN WITH THE PASSAGE OF TIME.

Chandra Shekhar Dubey: *These words have grains of truth, but these could be seen in different perspective in ontological way. Natural wind exists as a constant moving away from itself, but artificial wind moves from*

one place to another in seemingly contrary directions. True relationship, true persons are timeless metaphor for permanence and neither gaps nor time nor distance can stale these. Nevertheless, your words carry the wisdom of the modern age where self-interests define the boundaries of human relationship, and this is necessarily conditioned by time and space. My words can sound abstract in this material world, but these have strains of Sufi thoughts.

49. IT IS THE SOLACE OF GOING BACK TO THE EVENTUAL 'HOME' THAT KEEPS ONE ALWAYS IN RIGHT SPIRITS IN TIMES OF DESOLATION.

Shyam Sunder Tiwari: *One becomes at home in one's home.*

Author Kumar: *Very true.*

Shyam Sunder Tiwari: *Then it may not be a home at all. Home is where one feels homely.*

Author Kumar: *Exactly this is what the thought implies*

Manju Ailawadhi: *It could be, because however uncongenial the atmosphere*

in the 'home' may be but the fact remains that one finds whatever degree of 'solace' is destined for one, in that place only.

Shyam Sunder Tiwari: Home is not the name of any building. It can be forest, tree, state, country, farm hut, hill top or any place where you feel homely. For some people work is home. Some place where one feels good and comfortable. For some even prison is home. It will be unfortunate for those who can't feel homely anywhere.

50. UNCOMMON ARE THE WAYS THAT TRANSFORM THE 'EXTROVERT' INTO AN 'INTROVERT' AND THE OTHER WAY AROUND.

Manju Ailawadhi: *Certainly. For the twists and turns of life are such that one never knows what lies ahead, and one keeps compromising with situations as they arise.*

51. EVEN AN 'AEROBICIZED' CHEERLEADER SOMETIMES FAILS TO GULP DOWN AND DIGEST THE BONE THAT ONCE, IN ONE UNFORTUNATE MOMENT, GOT STUCK IN HIS THROAT.

Manju Ailawadhi: *Bones never could get down the throats of humans, even though some daring ones in some*

45

moment of 'sheer bravado' thought themselves differently gifted to be able to' manage' it like many other activities.

Author Kumar: Dr. Manju may be correct, but I preserve my bone of contention on this aspect.

52. IT IS THE 'BONE' IN THE NECK THAT DOES NOT LET THE PERSON BOWS PROPERLY.

Shyam Sunder Tiwari: To bow to someone means accepting inferior position for the self. It is for the person to either take it or put the blame on the neck bone to avoid it.

46

Author Kumar: *Putting the blame on the neck is a better option for one can always use it as an excuse and thus avoid ' inferior position for the self.*

Shyam Sunder Tiwari: *People are superior and inferior in different spheres of abilities and self respect is essential for all even though some are born in toughest to survive body and mind naturally and they do have their right to hold their head high and need not bow to others just because others are born differently. Respect to*

be admiration and not surrender. I like never surrender attitude.

Manju Ailawadhi: *The 'bone' in the neck sometimes becomes a good excuse for an attitude which otherwise would not have been possible. But that said bone manages to save the dignity of a person in crucial, trying times.*

53. THE 'SCHOOL' THAT WASH AND LEAD A GROWN UP BRAIN TO THE INITIAL FORM PUTS A SIXTY FOUR DOLLAR QUESTION ON THE EARLIER ATTENDED CENTERS FOR LEARNING.

Shyam Sunder Tiwari: *Instinct to survive is inherently the greatest school of self*

education, and it is open to all animals including us humans. Learn to survive or perish are only two possible options are open here.

Author Kumar: *Yes, that is true beyond doubt.*

Manju Ailawadhi: *There is no bar to the age of learning, and we can learn from anyone, anywhere.*

54. WHEN YOU ARE NOT ABLE TO GIVE BACK EVEN A TINY AMOUNT OF THE PAIN OTHER PEOPLE INFLICT ON YOU, YOU FIND AN OUTLET IN MISTREATING YOURSELF MORE BADLY THAN THEY DO.

Manju Ailawadhi: *And punishing your*

own self cannot purge the ills of others. But sometimes one is unable to retaliate/pay back in one's own coin and eventually all ills spring from there.

Author Kumar: *Yes very true but some think that by doing so they*

can at least 'purge' them the ill(s) around.

Manju Ailawadhi: *No inflicting pain on one's own self is neither dole nor advisable, for how can one think things /circumstances that surround*

one will change for the better after taking this course of action. Therefore, to my mind, the only best option is to have no expectations and retrieve in your shell. Another thing that needs to be stressed upon is that if we wish to spare our loved ones of some pain, we can only gently guide them, but we cannot live their life for them nor change their destiny which will be an outcome of their own actions. Try to help others but certainly not at the cost of torturing one's own self. This is really not done.

For finally we all are answerable for our deeds/ doings on the day of reckoning.

55. APART FROM THE NATIVE, BOTH 'HOME' AND 'TOWN' BECOME THE MOST EXPENSIVE FOR LIVELIHOOD EXCLUSIVELY BECAUSE YOU ARE EXPECTED ONLY TO DO YOUR DUTIES MINUS EVER ASKING FOR THE 'PRIVILEGES' OR 'RIGHTS.'

Manju Ailawadhi: *Anything that is one way traffic does prove to be expensive, for, after a certain point of time, it starts weighing heavily around the neck, and definitely this lopsidedness creates an imbalance leading to much mental torture.*

Author Kumar: *and this pain speaks to most, the world out the nest, really is.*

Shyam Sunder Tiwari: *When Muslims were rulers for 600 years, locals were slave, and when British were leaders for 200 years, once again locals were slaves, and now politicians and business houses owners are rulers and still locals are slave.*

56. THE PROPORTION OF RESTLESSNESS FROM THE CIRCLE DETERMINES THE TIME A PERSON SPENDS ON HIMSELF.

Author Kumar: *Restlessness and selfishness are two different aspects I*

believe.

Manju Ailawadhi: *If the 'circle' does not ensure a feeling of harmony or genuine goodwill then it breed discontent and 'restlessness.' Not to suffer suffocation then the only ray of hope seems to be in turning within and 'spending time with him' in a constructive manner.*

Author Kumar: *That's true.*

57. A "CURSE" AND A "BLESSING" OFTEN COME IN DISGUISE; THEREFORE, BOTH REMAIN UNCLEAR OF THEIR MAGNITUDES TILL THE LAST.

Shyam Sunder Tiwari: *Wish is an imagination of an ideal wished outcome.*

Author Kumar: *True for, in this case, neither of them will ever be able to influence the state of mind that come as a sequel of the same.*

Manju Ailawadhi: *True. One really cannot be certain whether a thing/ situation is a blessing or a curse until things have moved forward, and then too sometimes it dawns very late whether it was a blessing or not.*

Tripti Tyagi: *Very true sir and the best example are seen with <u>Macbeth</u>.*

58. 'SOME' WRONG ASSESSMENTS ARE ENOUGH TO BRING THE 'BLOODLINE' TO AN 'END' AND EARN THE ENTIRE LINEAGE A NAME SYNONYM TO 'BLOCKHEADS' THAT HUMANITY EVER HEARD.

Manju Ailawadhi: *Aptly observed. Sometimes wrong decisions are so irrevocable that they change the entire course of an otherwise well chalked off future, and then nothing remains except for lifelong repentance, and regret that now the route cannot be steered in another*

direction.

Author Kumar: *and therefore, due and proper homework need to be done before giving an idea the shape of reality.*

Shyam Sunder Tiwari: *Life is all kinds of experiences so don't give too much credit to least credit worthy wrong moments those may happen by accidents.*

Author Kumar: *Yes it sounds good but to some, it may not be possible to do away with them altogether.*

Author Kumar: *True. Also, a renowned poet had said elsewhere that '...fools jump in where angels fear to tread....'*

Tripti Tyagi: *Fools are always hailed as fools even if they save the entire lineage. Shakespeare understood them the most even then he calls them idiots.*

Author Kumar: *yes.*

59. IF A 'KNACK' HAD SURVIVED THE MAXIMAL REBELLIOUS NATURE IN THE EXTENSIONS DURING THEIR SPRINGTIME, THEY COULD BOAST OF HAVING ORIGINATED FROM A PRAGMATIC "BLOODLINE".

Manju Ailawadhi: *Yes that which courses*

in the blood don't meet a premature end remains dutifully faithful!

Author Kumar: *Very true.*

Author Kumar: *But the patience and confidence one can be confident of him are more than enough to ascertain that 'black dot' does not come up on the white sheet that the predecessors could maintain despite all odds.*

60. 'TEARS' AND 'PAIN WITHIN' OFTEN FAIL TO CONSTRUCT THE DESIRED 'TIE-UPS.'

Manju Ailawadhi: *Yes until and unless the*

tears are generated by a genuine pain since there is no harmony between the two, they fail to have a desired effect ... with the result that they fall flat.

Tripti Tyagi: *Some do not comprehend tears as well because they generate their own ideologies all around and contemplate all at same. Jimmy never is able to judge Alison in look back in anger.*

61. A 'DEAD END' MAY NOT NECESSARILY MEAN THAT THE JOURNEY HAS COME TO A CLOSE.

62. A "DEAD END" CAN ALSO MEAN THAT THE JOURNEY OTHER THAN THE ONE THAT HAS ALREADY UNDERTAKEN IS AT HAND.

Author Kumar: *Yes, undoubtedly.*

Manju Ailawadhi: *True enough, dead end also signifies that some other greener verdant/ avenue has been laid open for the traveller, and henceforth he has to move on that new path.*

63. IT IS THE KILLING OF "CHILDHOOD" THAT BRINGS DEATH TO "YOUTHFULNESS".

Manju Ailawadhi: *I think when one tries to kill the past somewhere we are also delegating the present into oblivion.*

Author Kumar: *Maybe but I have my own reservations on the argument.*

Author Kumar: *Maybe/ May not be. But, certainly the aspects put forth do deserve thorough thoughts.*

64. THE SADDEST COINCIDENCE CAN ALSO BE WHEN CO-PASSENGERS START TO DETRAIN ONE BY ONE IMMEDIATELY AFTER A 'RAPPORT' IS BUILT AMONG THEM.

Shyam Sunder Tiwari: *One of the parts of education is to discriminate and detain rather than educating all. Such discrimination and filtering process is seen in every sphere of life.*

Author Kumar: *No doubt at all.*

Manju Ailawadhi: *This can happen in any and every sphere of life; just when we imagine that a rapport has been built it is shattered by some forces/ulterior motives/ that a non-schemer may never comprehend.*

Author Kumar: *Yes, that also is a fact that just cannot be denied too.*

Shyam Sunder Tiwari: *Our life is for the self and selfishness is inherent part of it. Being liberal is a learnt process by the intelligent being who may be able to*

think beyond the self.

Tripti Tyagi: *Self complacency ironically excels the trust and human belief. The hero pip also ignored Joe in London; however, later he realized the absolute truth of the world.*

65. THE DEGREE OF 'IDIOT' YOU ADJUDGED TO CAN BE FIGURED OUT FROM THE SHAPE THAT LINES HAVE TAKEN ON BOTH THE EYEBROWS AND FOREHEAD.

Manju Ailawadhi: *One needs a discerning eye for it; all are not so richly bequeathed to read the lines.*

Author Kumar: *Not very sure. Maybe we*

all have that discerning eye but prefer to remain blind only to ascertain that the other too, live in this confusion.

Author Kumar: *Yes, that is true but as Dr. Manju has rightly said that an idea, at least, can be derived to some extent provided one has that 'discerning eye.' But hardly any is blessed for it.*

Deshraj Tyagi: *If we admit that hardly any is blessed for it. Suppose we find anyone having this ability. It has no meaning. A single sparrow cannot*

make spring.

66. WE OFTEN END UP ALONE, SIMPLY BECAUSE THE TIME OF MOUNTING WAS DIFFERENT FOR ALL.

Manju Ailawadhi: *Since we make our entry in this world alone, most remain alone throughout. No one knows what the other person's journey is/has been like. We all bear our crosses alone.*

Author Kumar: *Very truly said.*

Shyam Sunder Tiwari: *We are never alone even though we may feel we are alone is only a paradox of understanding.*

When we came here, we were not alone, and when we will go away, we will not be alone. We are just getting integrated and disintegrated in different forms within a form which is dynamic and just suitable for us for experiencing intelligence, knowledge and lots of love. We do exist, and we also don't exit.

67. 'STRINGS' LOOSE, MERELY FOR SOME OVERLOOK 'ATTACHMENTS' OF THE 'DESIRED STRANGLEHOLDS.'

Manju Ailawadhi: *Mostly we are guided by our feelings but sometimes we*

instigate our feelings to act/ behave in a desired fashion.

Shyam Sunder Tiwari: *We all are strangers till we starts caring for each others.*

68. EVEN THOSE WHO ARE NOT ABLE TO FIND 'THE ONE' TO ACCOMPANY, SEE A FEW TO ESCORT ONE DAY.

Manju Ailawadhi: *The inevitable truth which no one can shy from.*

Shyam Sunder Tiwari: *Even when there is none visibly to escort, to one in dire scenario there is always someone invisible for all.*

69. THE 'JOURNEY' SIMPLY CAN NEVER BE 'SMOOTH' FOR VERY LONG.

Manju Ailawadhi: *Because life is not predictable, and no one was assured a stable life.*

Shyam Sunder Tiwari: *Smooth journey without adventures sure will be very boring.*

Author Kumar: *Very true Dr.Manju ji and Sh Shyam Sunder ji.*

70. TOO MANY HELPING HANDS CAN ONLY HELP YOU LOSE A 'GAME'.

Shyam Sunder Tiwari: *It is all in the game irrespective of win or lose.*

Manju Ailawadhi: *And that comes as a big, sudden surprise.*

Shyam Sunder Tiwari: *Unless help is demanded, it should not be extended.*

71. 'PAMPERING' IS ALSO ONE FORM OF "ENCASHMENT" OF FUNDAMENTAL HUMAN NATURE.

Shyam Sunder Tiwari: *Pampering is blackmailing.*

72. 'WORDLY RELATIONS' POSSIBLY ARE TO FELICITATE THE SENSE OF 'BEING IN ASSOCIATION.'

Shyam Sunder Tiwari: *Our knowledge is associated one.*

73. WHOEVER TOYED WITH 'TIME' LOST MUCH BEFORE THE GAME BEGAN.

Manju Ailawadhi: *Yes for time cannot stand being toyed with.*

Author Kumar: *still not many understand and therefore often are out to test their hold over the artistry time and again.*

Shyam Sunder Tiwari: *Some games are played for losing.*

74. IT IS THE RHYTHM THAT ADDS DAILY A LINE TO THE SONG OF YOUR LIFE.

Manju Ailawadhi: *Everyday a new melody springs in the song of life.*

Tripti Tyagi: *However in modern times, it is free verse that is added to our lives every day. A famous poet Chinveera Kannavi says so.*

Author Kumar: *and therefore, in the absence of the primary component 'rhythm', not many could compose either a complete song or even a song either.*

75. 'EXPECTATIONS' OFTEN PUT YOU TO UNREST, MERELY FOR THE PERSON BEING LOOKED FORWARD TO, "FRAME" HIMSELF INTO AN UNEXPECTED ONE, SOON AFTER HE HAD PERCEIVED OF THE SAME.

Manju Ailawadhi: *It at times gives an*

inflated opinion of self even to un undeserving one.

76. THE 'ONE' WHO CONSCIOUSLY ACT 'INSTRUMENTAL' AND SEIZE IN THE SEQUEL THE BREAD 'OTHER' IS BESTOWED WITH- ONLY TO ACHIEVE A NAME SYNONYM FOR "DREAD"- UNCONSCIOUSLY DO SOMETHING ENTIRELY UNPARDONABLE.

Manju Ailawadhi: *Every consciously done act that is detrimental for another deftly is unpardonable, for the mere fact that it has been done deliberately, and therefore the consequences of such actions must also have been known.*

Author Kumar: *Unfortunately, a*

'crooked' knows the consequences but to him, the priorities are always very different. GOD forbid all from this coterie of wrong mindsets.

77. IT WAS NOT ALONE THE COUNT DEMONS GREW IN, BUT THEIR NATURE INTENSIFIED TOO, WITH THE PASSING OF TIME.

Manju Ailawadhi: *Because everything moves a degree further gradually.*

78. IT IS THE 'OTHER' PARTNER IN LIFE WHO REMINDS THROUGHOUT, OF VOWS' TAKEN ON TYING THE "NUPTIAL KNOT".

Manju Ailawadhi: *Some do it incessantly, but conveniently forget their contribution to it, failing to*

understand that nothing can be a one sided affair.

Author Kumar: *Yes that can be an easy way out rather than to confront any 'unforeseen', by virtue otherwise.*

79. IT IS OPPORTUNE FOR ALL TIMES TO REMAIN OUT OF SIGHT/MIND OF AN 'UNSCRUPULOUS' MAN.

Author Kumar: *simply for they are always out to hunt the innocents/shirkers and when to fail to nab eye/prey on their own ones.*

Manju Ailawadhi: *Better any day for there is no level to which they can stoop to*

satisfy their ego.

80. THE UNETHICAL 'DEEDS' JUST CAN NEVER AVOID THE DUE 'REPERCUSSIONS' EVEN IF ONE HAD CHOSEN TO BE ON THE BACK FOOT IN NO TIME.

Manju Ailawadhi: *What is once set in motion its repercussions cannot be avoided, even if that step might have been taken hesitatingly.*

81. 'HEART' AND 'BRAIN ARE TWO DIFFERENT ENTITIES FOR BOTH CARRY ANTITHETICAL MINDSETS.

Manju Ailawadhi: *And by turns they propel us forward, sometimes the heart takes precedence and at others the mind. It is a see-saw.*

Author Kumar: *Very well defined with perfect philosophical perspective.*

Manju Ailawadhi: *Yes they do not move in tandem to each other. They vacillate in a see-saw motion, one taking precedence over the other by turns.*

Author Kumar : *and this they do with a deliberate motif.*

82. THE QUANTUM OF 'PEACE' ONE ENTITLES TO DEPENDS ON THE DEGREE HE COULD RESTRAIN IN EVERY CONDUCT THE ASSOCIATE INHABITANTS INVOLVE ORDINARILY.

Manju Ailawadhi: *True enough, if one adopts a lassies- faire attitude. Also, I*

believe if one abandons reason then too one can achieve 'peace.'

Author Kumar: *Yes, you are right for things to become comfortable with the one who abandons reason.*

Author Kumar: *Well, I believe the very concept of the group seem to come true for we can debate and get equipped with the aspects which we otherwise always remain blissfully ignorant of.*

83. NO WAY CAN IT BE 'SCORE CARD' ONE OBTAINS AFTER EVERY TEST FOR IT IS 'END RESULT' THAT RESERVES THE "OVERALL PERFORMANCE".

Deshraj Tyagi: *End result is the outcome of due diligence, concentration, and ability to discremate, not have been followed earlier.*

Manju Ailawadhi: *Sporadically one may have performed well, but the end result can be gratifying only if one has been consistently diligent.*

Author Kumar: *I believe Dr. Manju Ji would agree with me as the 'end result' is also the compiled one of all*

the sub-parts on a whole.

Deshraj Tyagi: *Hundred percent true.*

84. IT IS THE LACK OF ABILITY TO SINGLE OUT THE PRIORITY THAT ADJUDGES THE 'TRAIL' YOU LEAVES BEHIND.

Manju Ailawadhi: *If more could categories priorities, half the ills of the world would be over.*

Author Kumar: *Very true.*

Deshraj Tyagi: *Ability is the prime factor, but I think not only due to ability but to shun the duty to revise and reassess the priorities continuously in an ever changing mindset due to*

unavoidable circumstances to achieve the desirable result

Author Kumar: *True enough, but I further would interpret it by adding to what you say for 'unavoidable circumstances' are again something which the ones are being talked about. take shelter under this 'garb time and again.*

85. ONE 'GOOD' IN A HUNDRED, IS A PASSABLE NUMBER TO ERADICATE ITS COUNTERPARTS.

Manju Ailawadhi: *Quite a positive way of thinking.*

86. IT IS THE LOVE FOR "SELF-ESTEEM" THAT WILL ASCERTAIN FOR 'GLOW' TO STAY AND NOT AD INTERIM ONLY.

87. THE IDENTITY BECOMES OVERNIGHT A 'KNOWN'- UNANTICIPATED COURTESY DEPLOYMENT.

Manju Ailawadhi: *And once deployed doesn't assure its permanence.*

88. ONE JUST CANNOT AVOID THE CONCLUDING NOTE ON THE FIESTA THAT HIS ARTISTRY TO CHOREOGRAPH 'EVEN A FEW' WAS AN ABSOLUTE DELUSION.

Manju Ailawadhi: *And some live happy in that delusion, shutting their eyes to reality/ refusing to admit it.*

Author Kumar: *...and when they are made to open their eyes, they found*

not even the shadow is following them.

89. A 'HEADSET' THAT BELIEVE IN 'MAKE OTHERS FIGHT, AND RULE' SIMPLY CANNOT BE FROM A KNOWN 'ORIGIN.'

Manju Ailawadhi: *One who encourages this mindset succeeds in landing all in trouble.*

Shyam Sunder Tiwari: *Game of an Outsider.*

Author Kumar: *Yes, the gamer can't be of the same origin.*

90. 'ENCASHMENT' OF "CONCERNS" SIMPLY CAN NEVER BE A PERMANENT FEATURE.

Manju Ailawadhi: *A sincere 'concern' cannot be encashed, for it was never meant for this purpose. Only an outward show may be encashed, but that coin too cannot be used again n again.*

Author Kumar: *Undoubtedly very fortunate are those who conclude that a sincere 'concern' cannot be encashed as some still are of the opinion that except "parents" each concern carry one or the other vested interests.*

91. ONLY AN 'IDIOT' OF HIGHEST DEGREE CAN MUSTER THE COURAGE TO RESCUE THE TRAPPED 'PETS' FROM A 'TORNADO'.

Manju Ailawadhi: *Naturally only an 'idiot' of the highest order can excel at this art and feel thrilled at his 'caliber' to do so.*

92. NOT 'ALL' ARE GOOD AT DECISION-MAKING.

Manju Ailawadhi: *Few are gifted with that acumen.*

Shyam Sunder Tiwari: *Intelligence is fuzzy and yet very decisive for the intelligent one. Indecisive lake intelligence. Not all humans are*

capable.

93. THE REAL AND A TRUE 'HERO' OF ALL TIMES CAN ONLY BE THE ONE, WHO TOOK THE PUNCTURED TROLLEY TO ITS FINAL DESTINATION SINGLE-HANDEDLY, FOR THE ASSISTANT LEFT SOON AFTER THE JOURNEY STARTED.

Manju Ailawadhi: *All kudos to such a soul.*

Shyam Sunder Tiwari: *Solo life for the best judged performance.*

94. NO PRICE CAN BE TOO HIGH FOR YOUR RESIDENCY THAN THE UNIT OF YOUR DWELLING SIMPLY BECAUSE OF THE ATTACHED RIDER – 'ONE WAY LIABILITY'.

Manju Ailawadhi: *Nothing can work sans crease if it is a one way liability.*

Author Kumar: *Yes, it may seem working but one day one do/had to conclude willingly or unwillingly that it never worked and the impression that initially was there was the 'modesty' of the other.*

Manju Ailawadhi: *Yes things cannot work indefinitely like that, one does come to the end of the tether, and maybe by then it is too late.*

Author Kumar: *very very late and that too, irretrievably.*

95. ONLY 'PARENTS' CRY, WHENEVER YOU ARE HURT.

Manju Ailawadhi: *Yes only parents feel the hurt. Despite their boundless love they leave us, but leave one inconsolable if they depart before the due time.*

Chandra Shekhar Dubey: *True feelings evolve from the true bonds and from the biological determinants. Parents feel for their children in a language which has neither external motive nor apparent meaning but apparently autonomous feeling saying "I am" in your own voice.*

Rakesh Tyagi: *To add further the cry of your parents when you are hurt my not is visible but it is always there, and they try to do everything to ensure that you do not cry again.*

Rakesh Tyagi: *I happen to meet your father few time only. We in our family always remember him as educationist of profound vision whose basics were very clear.*

96. ONLY 'WEAK' PRONOUNCE THEM 'STRONG'.

Chandra Shekhar Dubey: *Strength is the creed of the brave and weapon for the*

coward. The term is relative therefore the utterance is passive acceptance of the other's might by the weak. Moreover, nobody shall appreciate the might of others without having the sense of owns own debility.

97. NOBODY WILL DO PREPARATORY FOR YOU SIMPLY BECAUSE HARDLY ANY COULD COMPLETE EVEN HIS.

Shyam Sunder Tiwari: *If you can pay for hiring others then others can do your work for you is a simple principle of engaging for your laziness or in-capabilities.*

98. THE NUMBER IS GOOD ENOUGH OF THOSE WHO DO WRONG HOMEWORK EVERY TIME AND THE OPPOSITE.

Manju Ailawadhi: *Because some are always struggling to excel at the despicable activity of fooling /misrepresenting (facts to) others.*

Author Kumar: *Yes, that is I believe very unfortunate on the part of those being talked about above.*

Shyam Sunder Tiwari: *Many don't at all do homework, leave aside a wrong home work.*

99. NOT "ALL" GET WHAT WAS PROMISED.

Shyam Sunder Tiwari: *Some promises are meant to be broken.*

100. 'ALLEGIANCE' IS OF-TIMES MISEMPLOYED.

Manju Ailawadhi: *Yes, it is twisted and turned and then used to advantage!*

Shyam Sunder Tiwari: *It is something somehow always exists in the vicinity of almost all powerful and wealthy people.*

101. ONLY A 'NEFARIOUS'GO ANY EXTENT AND REMAIN UNDETECTED.

Manju Ailawadhi: *Truly those given to 'nefarious activities' excel in the art of*

deception.

Author Kumar: *But not for all the times I suppose.*

102. THE 'NAME' GIVES SOME, THE FEELING OF WHAT THEY COULD NOT BECOME OTHERWISE.

Manju Ailawadhi: *Yes the 'name' is a camaflouge to hide behind.*

Shyam Sunder Tiwari: *Red Indians were given name as per the nature of the person. Indian names are often God Goddesses, Supernatural, Specialty specialist, Unique, devise and sometime funny like Pappu, Gudia.*

Author Kumar: *Very rightly said.*

Author Kumar: *Thank you very much.*

103. IT IS THE TORMENT 'WITHIN' THAT MAKES YOU A "MAN OF LETTERS".

Manju Ailawadhi: *Yes until something brews inside one, one cannot pour out a delicious drink.*

Shyam Sunder Tiwari: *Emotions are the key to the creativity from within.*

Author Kumar: *No doubt.*

Vasant Sharma: *It is said that the first book is generally an autobiographical one.*

94

Manju Ailawadhi: *Yes once fermented thoughts just spill out in the form of words.*

Rakesh Tyagi: *The message of these letters is in-depth and broad.*

104. AN 'UNTOLD' MAY ALSO HAD BEEN EQUALLY CLEAR OF HIS PRIME CONCERNS.

Shyam Sunder Tiwari: *Untold may have reasons to doubt as to why secrets are being hidden.*

Author Kumar: *May be.*

Shyam Sunder Tiwari: *One who does not speak out may also have concerns. See*

why Neta Ji Subhas Chandra Bose files were not disclosed and now they are being disclosed.

Author Kumar: *Very right.*

Manju Ailawadhi: *Keeping secrets or hiding things surely raises/creates doubts in one's mind.*

Author Kumar: *Yes, that is true.*

105. FAILURE FOR NOT ABLE TO WIN 'ONE' MAKE SOME SWEAR TO DEFEAT "ALL".

Manju Ailawadhi: *For they have a wrong perception that that 'one' is far above 'all' of them put together.*

106. OUTRIGHT SHOW OF 'STRENGTH' ALSO SPEAKS OF ITS "COUNTDOWN."

Shyam Sunder Tiwari: *Unprepared*

Sometime show of force backfires very badly as it was in Indo-China war for India and Indo-Pak wars for Pak. It is much better to be stronger than to show strength only for a wrong countdown shatter.

Manju Ailawadhi: *Yes most of the times a show of strength though done with an objective of terrorizing the other actually is making a fool of one's self only, for when the other one can see*

through the intention, the entire exercise becomes one in futility.

107. THE INTENT TO HANDPICK THE INNOCENTS CAN ONLY BE TO DEVIATE "ALL" FROM THE MAIN AGENDA.

Shyam Sunder Tiwari: *Innocents adults are those who have no choice or may have committed some wrong act unknowingly or under life saving pressure. Children are often treated as innocent as they may not have learnt to differentiate between good and evil. It is all about the capability of the brain to understand one's act*

and to perfectly judge it.

Author Kumar: *Right.*

Manju Ailawadhi: *Crafty ones have only one agenda in life, and that is to terrorize innocent ones under one pretext or the other.*

Author Kumar: *Yes, very true.*

108. ONLY 'WEAK' NEED DETACHMENTS.

Manju Ailawadhi: *I believe remaining sometimes attached quite demanding, and therefore the ' weak' ones prefer to steer clear of it.*

Author Kumar: *True enough and very rightly said.*

109. TWO 'IDEOLOGIES' CAN BECOME "ONE" ONLY IF NEITHER CARRY ANY.

Manju Ailawadhi: *Yes oneness of thought is v essential to move together in harmony.*

Author Kumar: *True. Though 'no ideology' also speaks of unity, but harmony will get maintained a different aspect altogether, I Suppose.*

Shyam Sunder Tiwari: *There are many dimensions and bringing them in just*

one will be horrible. What if you gel into single wrong aspect?

110. AN 'UNATTACHED' IS NEVER AT REST.

Manju Ailawadhi: *In life's journey all need a companion, even though there may be differences of opinions at times. But someone to share your ups and downs, whatever the state of the road may be.*

Author Kumar: *True enough.*

Shyam Sunder Tiwari: *World isn't without relationships, and it will never be.*

111. THE FINAL 'NAIL' IS OFTEN PUT IN BY THE MOST BELOVED.

Manju Ailawadhi: *Bcoz without that the coffin cannot b secure enough.*

Shyam Sunder Tiwari: *We have courts and jails for the errant countrymen. We have to punish our own evil else teaching of shrimad bhagwat Geeta, or Mahabharata will be of no use.*

112. THE TERM 'COURAGEOUS' CAN ONLY BE ATTRIBUTED TO WHO DO NOT HIDE HIM FROM ANY-BUT NEVER TO THE ONE WHO DO NOT REVEAL THE SAME EVEN TO HIMSELF.

Shyam Sunder Tiwari: *Complicated.*

Author Kumar: *Thought or the 'term'.*

Shyam Sunder Tiwari: *Courageous means ready to face the consequences of the activity in which one involves willingly for good reason. Terrorists can't be called brave as they are for wrong reason.*

Author Kumar: *The idea and the ones in mind is those who do it for a good reason.*

Shyam Sunder Tiwari: *One does not reveal to oneself, but one knows about oneself in one's own understanding,*

and one can only hide things from others which are normal unless it deliberately causes harm to good or may support bad. People don't come forward to help or support sufferers even though they see it every day are not courageous.

Shyam Sunder Tiwari: Getting involved in everything also deviates one from one's own path.

Author Kumar: I agree.

Shyam Sunder Tiwari: Be at peace and involve only in essential.

113. HATS OFF TO THOSE WHO EXCEL IN GETTING THINGS DELAYED IN THEIR FAVOUR TIME AND AGAIN.

Manju Ailawadhi: *Manipulators who have mastered this art to perfection often succeed in their nefarious schemes and thereby threaten the righteous ones, but time takes its toll sooner or later.*

Author Kumar: *Hope so.*

114. 'TIME' AND 'TIDE' WAIT FOR THE ONE WHO DO NOT WAIT FOR EITHER OF THEM.

Manju Ailawadhi: *One, who carves his own way, gets what he wants.*

115. ONLY A 'LATERAL ENTRANT' CAN PRACTISE AND ADVOCATE THE BACK ENTRY AS THE 'MAIN' AND VICE VERSA.

Shyam Sunder Tiwari: *So called the ordinary people have to wait for the special person's entry.*

Author Kumar: *Yes the irony of the times.*

Manju Ailawadhi: *Some somehow manage by pulling strings much to the loss of the deserving ones.*

116. IT IS THE FEAR 'WITHIN' THAT KILLS YOU FIRST.

R.K.Chadha: *Simple one liner like these can have telling effect. Fear within drains out our energy and will to*

succeed when we know that fear is unjustified or just a phantom.

117. THOSE WHO SAY 'COULD NOT READ', IN FACT, ARE ALWAYS THE FIRST TO READ THE "WRITING."

Manju Ailawadhi: *I think because such ones always intend to keep themselves*

Camouflaged under sheets of innocence/ignorance.

Shyam Sunder Tiwari: *At times, one may have to read in between the lines.*

Author Kumar: *This is exactly what the thought above has done.*

118. IT IS THE CONSCIENCE THAT MAKES A GUILTY FEEL AS IF HE IS THE ONE FOR THE CENTER FOR DISCUSSION AROUND.

Shyam Sunder Tiwari: *Those with dead conscience feel nothing, else all others feel about their deeds or karma in their conscience.*

Author Kumar: *This is a fact, unfortunately.*

Manju Ailawadhi: *Only one who has some remnants of the conscience left can feel guilty, those who manage to kill their conscience are even deprived of feeling 'guilty.' Such a pitiable state.*

Shyam Sunder Tiwari: *While pure consciousness in people lets them know the fact very clearly in their own understanding, yet, it is the nature of the only lets them down the drain to fall pray of bad nature of addiction to wrong doing.*

Author Kumar: *Very well said Manju ji and Shyam Sunder ji.*

119. PUTTING ANYTHING IN BLACK AND WHITE AND PASSING THE SAME TO THE PERSON IT DIRECTLY REFERS TO, SHOULD MAKE THEM REVISIT/ REVIEW THINGS AFRESH, AT LEAST FROM THAT MOMENT ONWARDS.

Manju Ailawadhi: *A good n positive way of*

thinking! Only if it followed in the true spirit, wouldn't the world become a haven of peace? But, there is really no harm in hoping.

120. "FEATHERS" HIDE 'TRUE SELF.'

Shyam Sunder Tiwari: Decor is to hide underneath truth.

Author Kumar: Very rightly said.

Manju Ailawadhi: Feathers are like a mask they hide the reality and project an entirely different one.

Author Kumar: Well, it depends on the kind of person they are to be

conferred upon.

Shyam Sunder Tiwari: *Feathers are recognition of some special lifetime achievements. They do not describe personality in total of any person but symbolize particular ability with which they associate as honor.*

121. ACTIVE OPPONENTS ARE LESS HARMFUL THAN THE PASSIVE ONES.

Shyam Sunder Tiwari: *Inert world is useless like transparent and the one of friends mirrors and shows some reflections of your good and bad acts.*

122. DISPROPORTIONATE WORDS OF PRAISE MAY BE A 'MOUSE TRAP'.

Manju Ailawadhi: *Yes for they amount to flattery, and that surely is a honey-trap.*

Author Kumar: *and especially when told time and again that you are different from others, for you are very down to earth and always hated the ones who flatter.*

Shyam Sunder Tiwari: *While encouragement is often needed to support the person who has suffered immediate failure, it is to be avoided*

as flattery.

Author Kumar: *Yes, of course, those cases are/may to be taken else wise.*

123. LUCKY ARE THE ONES WHO ARE ULTIMATELY GRANTED THE WISH TO LIVE ALL ALONE ONE DAY, AS THEY WERE NEVER COMFORTABLE IN THE COMPANY OF ANY.

R.K.Chadha: *We all understand the beauty of solitude at some point of time. Sadly, most of us never experience it.*

124. LIFE 'AFTER' SHOULD BE BETTER... AND THUS, THE CYCLE MOVES ON AND ON.

Manju Ailawadhi: *Yes we can always hope for a better 'after' life, for we give the*

world the best of ourselves.

125. GENERATIONS WILL REAP WHAT YOU SOW TODAY.

Tripti Tyagi: *so what media has to do with it which conveys false and participates in? ruining the foreseen generations.*

Shyam Sunder Tiwari: *Yes, both good and bad, fortunately, or unfortunately.*

126. THE TERM 'CAKEWALK' HAD NEVER BEEN IN THE DICTIONARY OF 'ALL'.

Manju Ailawadhi: *Despite that 'some others' did manage to have it.*

Author Kumar: *Yes, simply because they*

excel in this art only.

Shyam Sunder Tiwari: *More challenges are for those with disability of any kind, gifted with poverty right at the time of birth and being born in the society of the other people who think themselves*

of some superior kind. We all see this but rarely understand it fully and never solve this problem even though we may not like it at all. Mental poverty is more severe problem than physical poverty and wealth poverty.

Author Kumar: *Yes, but I believe that*

'Mental poverty...physical poverty and wealth poverty' -all are interlinked.

Shyam Sunder Tiwari: *India Government was keeping its people under wealth poverty for several decades. In Germany those have no car or computer, Government gifts them. In India, some states gifted TV and other items only during elections and from stolen wealth but not under any serious understanding of the need of the people. All people have basic rights to survive. Extra-ordinary abilities*

can be appreciated or rewarded but those who are without must not be subjected to insults of not being special.

127. THE MINDSET TO RELISH UNDESERVED BREAD IS BOUND TO STARVE THE GENERATIONS LATER.

Manju Ailawadhi: Not only the 'generations Later' but the same age sometime late in the day.

Author Kumar: Yes, the process may start in the same generation.

Shyam Sunder Tiwari: Extra bread eaten is always a share of someone else.

Author Kumar: *Very right*

128. EACH THINKS OTHER 'UNWORLDLY,' THE MOSTLY.

Shyam Sunder Tiwari: *When Rama and Rawana are recognized for their act in Ramayana, Sita and Lakshmana get sidelined even though they are one of the best characters in themselves. Moral of the story can accommodate only one Hero and one Villain at best even though lot many play their great role in the happening. Other than Jesus who do you think was a character of*

importance in the Bible? There are very many good people all the time who sustain the society and carry the flag of good will to humanity in all times.

129. ONLY 'REMINISCENCES' WILL BEAR THE TESTIMONY OF YOUR EXISTENCE.

Manju Ailawadhi: *To be etched in someone's memory forever would be no mean achievement, isnt it?*

Author Kumar : *Yes, that is true.*

Shyam Sunder Tiwari: *As per Stephen Haw king's philosophy, everything exists*

forever in time, and we only travel in time to see things in increasing time as they do already exist at sometime somewhere. We have no way yet known to go back in time. We do know that people existed before us, and all of them must be having love for life, and their life must be full of some story and yet they hardly make any sense to us other than those very few who created history that of God or believers loving and serving God or being some kind of Devils that were eliminated by some God. Rest of the

A FEW RESPONSES TO THOUGHTS SWEET AND SOUR

people is just fillers of space like wild animals who live and die in time.

130. PARENTS NEVER LEAVE IN THE LURCH.

Manju Ailawadhi: *Sanjeev there are all kinds in the world. Your feelings can be understood because you lost your mother at a v young age.*

Author Kumar: *Yes my bhabhi had no choice but to obey the ALMIGHTY and my papa had to ascertain therefore that the then due responsibilities are taken care of and the day he completed all, he too, left*

121

immediately 20 days after.

Shyam Sunder Tiwari: *I, you and many others may lucky, but many find their parents don't care type even for their own new born. It is very subjective statement, and we may wish for great parents.*

Author Kumar: *very rightly said.*

Tripti Tyagi: *there are some like Lawrence's Morel is actually an archetype in the post-modernist era.*

131. A JOURNEY INTO THE BEAUTIFUL PAST REJUVENATES AND READIES YOU FOR THE FUTURE.

Manju Ailawadhi: *Yes it forlifies one immensely.*

Tripti Tyagi: *Freud calls it a dream.*

Tripti Tyagi: *a repressed wish.*

132. ONES WITH 'OBSESSION FOR CLEANLINESS' IS THE WORST COMPANY TO BE IN ASSOCIATION.

Manju Ailawadhi: *Obsession with anything is unhealthy and takes a severe toll.*

Author Kumar: *But the saddest part is 'they' think that they can be healthy thanks to this obsession only.*

Author Kumar: *very true.*

Tripti Tyagi: *sometimes it refers to a kind of caused psychosis as Dorris Lessing's Mary Turner suffers from.*

133. CLOSE RELATIONS TAKE YOU FAR, PROPORTIONATELY.

Manju Ailawadhi: *The proportion in which they can derive any benefits from us?*

134. MOTHER'S LOVE IS SUPREME.

Manju Ailawadhi: *V true, but some realize this Only after her departure, and some are deprived of it at a v early stage of their lives.*

Author Kumar: *very rightly said.*

135. HARSH WORDS NEVER DIE WHEREAS 'GOOD' LIVE AFTER THAT.

Shyam Sunder Tiwari: *Dirt is always too be washed even though it keeps coming in time.*

Author Kumar: *Very truly said.*

136. 'REASON' HAD NEVER BEEN A HEART'S CUP OF TEA.

Shyam Sunder Tiwari: *Heart's power of reasoning is known only to the heart and is often away from brain's logic.*

Author Kumar: *Yes, a heart has its own*

reasoning for it.

137. ONE SIDE ADJUSTMENT OF 'NATURE' SIMPLY WILL NEVER WORK.

Manju Ailawadhi: *Naturally enough adjustment will have to come from both the parties, yes the proportion need not necessarily be the same, to make things workable it has to be a two way traffic.*

138. 'BACK BENCHERS' ARE MORE CREATIVE.

Manju Ailawadhi: *Sometimes yes and sometimes not, for some gain expertise in developing worthless qualities.*

Author Kumar: *Yes you are right.*

Shyam Sunder Tiwari: *Backbenches get less exposure and get less exposed.*

Author Kumar: *Very true.*

Shyam Sunder Tiwari: *First bullet hits the BSF even though they are only security personals and not the Army Force to fight a war.*

139. MODESTY HAS NO HARM.

Shyam Sunder Tiwari: *Modesty may be taken for ride and harming the person of decency. World is tug of war to survive and no one type of solution*

if fit for everything.

140. 'INSECURITIES' DO NOT LEAVE EVEN AFTER YOU ARE SECURE.

Manju Ailawadhi: *For those insecurities are self-created by those that lack self-confidence.*

Author Kumar: *May be, may not be.*

141. THE SO CALLED BLIND SUPPORTERS ARE ALWAYS THE FIRST TO BLOW THE TRUMPET OF YOUR COUNTDOWN.

R.K.Chadha: *Nice one liner. In our politics obsessed world, it is every demagogue's wish to have legions of blind supporters, but these supporters*

often become Achilles' heel of their leader.

Manju Ailawadhi: *Were they merely blind followers or fence sitters that sway with d breeze?*

Author Kumar: *Fence sitters in the garb of a blind supporter*

Shyam Sunder Tiwari: *Yes, there are plenty of blind supporters, but they often have their own reasons for being so blinded knowingly and willfully.*

142. AT LEAST, CHRONICLES SHOULD MAKE YOU WISER.

Manju Ailawadhi: *Yes, provided one*

adheres to them with sincerity.

Shyam Sunder Tiwari: *It all depends on which side of ideas one picks up and starts using them. I think, good and bad are always in some kind of balance, and it is never one sided tilt.*

Author Kumar: *I agree.*

143. YOUR PEACE OF MIND IS ADVERSELY AFFECTED BY THE DISTURBANCE IN OTHER'S.

Manju Ailawadhi: *Well it really depends on how much you are connected with the 'other'.*

Author Kumar: *Yes the more, the more.*

130

Shyam Sunder Tiwari: *Our knowledge is only by the harmonics of disturbances. Peace of mind comes from understanding of everything including good, bad and worst.*

144. THE ONLY OPTIMISTIC IS THE PERSON, WHO CONTINUES POSING AS AN IDIOT IN THE HOPE THAT AT LEAST, ONE WILL TAKE HIM SERIOUS ONE DAY.

Author Kumar: *Yes, that will be an ideal approach one should go for.*

Shyam Sunder Tiwari: *Seriously speaking nothing should be taken seriously unless it hurts someone.*

Author Kumar: *Yes I agree.*

145. MEMORIES OF THE PAST FILL SWEET IN YOUR SOUR PRESENT.

Manju Ailawadhi: *That is exactly what memories do. They wipe away the unseen cobwebs n add a gloss to the past n then pour the same nectar in the sometimes unpalatable present making it a delectable dish.*

Author Kumar: *Very true.*

Shyam Sunder Tiwari: *Good sweet and sour recipe to enjoy.*

146. THOSE WHO PROTECT YOU FOR YOUR EVIL DEEDS, IN FACT, SHIELD THEIRS.

R.K.Chadha: *Absolutely. True friends admonish you when you do evil deeds. They neither applaud you for your wrongs nor support you and if they do they are either insincere or are looking for company in their own evil. Well said!*

147. ONLY THE 'INSECURE' BIND YOU MORALLY.

Manju Ailawadhi: *And little do they realize that morality also has many facets. What may b appropriate for one may not b suitable for another in a given situation?*

Author Kumar: *Yes.*

Shyam Sunder Tiwari: *Moral status may change once insecurity is lost. Moral of the moral itself is unstable.*

148. THE COMPLIMENTS SHOULD NOT DRIVE YOU AWAY.

Author Kumar: *Well, the notion is that one should not take the compliments very seriously for they may hinder in your natural enthusiasm to do the works at hand.*

Shyam Sunder Tiwari: *What for the compliments are in any way? Beware and don't go crazy when someone says I wasn't even complemented for*

all that I did. People are throwing away (perhaps fake) awards / rewards that were supposed to be some kind of complements, now being used to insult the Government of India itself. It is happening all the time.

Author Kumar: very painful but very true, too.

149. THE WIDER PUBLICITY OF ANY PRODUCT DEPENDS UPON ITS USELESSNESS, RELATIVELY.

Shyam Sunder Tiwari: Confusing billion minds by glamorous advertisements.

Manju Ailawadhi: Agreed fully. Only

products that have a dubious reputation r dependent on ads and these are high skilled jobs to mislead the gullible recipient.

150. IT IS THE OBSESSION AND NOT 'DEDICATION ' ALONE; THAT CAN BRING LAURELS TO YOUR PRIORITIES.

R.K.Chadha*: Excellent thought! Dedication can bring some success, but it is obsession that brings about revolution. Think of the Buddha, Michelangelo, Newton or Archimedes - they were all obsessed with something or the other.*

151. DESPITE ALL, BLOOD IDENTIFIES ITS GROUP ONE DAY.

Shyam Sunder Tiwari: *Blood groups but problem is more severe with genes.*

Author Kumar: *Very sarcastic but true.*

Shyam Sunder Tiwari: *Very natural fact of life as we know scientifically now. Perhaps we are changing all the time very naturally due to vast world, into new genetic forms either to get adopted or to vanish forever.*

152. ONLY THE "GOOD" CARRIES THE FINAL VERDICT.

Manju Ailawadhi: *Yes, beyond any doubt.*

Rakesh Tyagi: *Sir, I wholeheartedly*

agree with you. I have seen it many times that if you are good from inside, God takes care of you & you need not worry for anything.

153. NOT 'ALL' ARE BORN WITH ADDITIONAL GIFTS OF GOD.

Rakesh Tyagi: *Rightly said, God gives exceptional qualities to only some.*

Kavita Tyagi: *Undoubtedly.*

154. NO GAME CAN IS 'JUSTIFIED' IF PLAYED AT THE COST OF YOUR BREAD AND BUTTER.

Manju Ailawadhi: *V right.*

Author Kumar: *very rightly said.*

Tripti Tyagi: *True sir.*

Rakesh Tyagi: *I feel that a game should be played with genuine feelings and should be won with sportsmanship.*

155. THE MORE EFFORTS THAT WERE MADE TO ENCIRCLE 'GOOD, THE MORE 'EVIL' LAY BARE.

Rakesh Tyagi: *One has to be more practical & hard working to keep the good as evil is always exposed.*

156. EVIL SUCCEEDS ONLY TO TAKE THE DOER TO ITS ACTUAL DESTINATION.

Manju Ailawadhi: *But the doer lives in a world of make- belief, thinking there*

couldn't be anyone more righteous.

Rakesh Tyagi: *You are right sir. The success of Evils is temperary, and they are hindrance in our work for very short period. One should not worry about them.*

157. SHORT TERM BENEFITS FETCH LONG TERM REPENTANCE.

R.K.Chadha*: There are plenty of such one liners which make you smile and reflect. We are often blinded by short term gains and lose sight of real objectives and goals.*

158. A PARENT NEVER FINDS AN EXCUSE TO LEAVE YOU ALONE.

Manju Ailawadhi: *I think when people don the garb of parenthood priorities change and they remain fixated to the demands of their progeny.*

Author Kumar: *Maybe.*

Rakesh Tyagi: *Probably he wants to enjoy your growth & style of working more and more in his presence.*

159. THE TERM 'CAKEWALK' HAD NEVER BEEN IN THE DICTIONARY OF 'ALL'.

Manju Ailawadhi: *Despite that 'some others' did manage to have it.*

Author Kumar: *Yes, simply because they*

excel in this art only.

Shyam Sunder Tiwari: *More challenges are for those with disability of any kind, gifted with poverty right at the time of birth and being born in the society of the other people who think themselves of some superior kind. We all see this but rarely understand it fully and never solve this problem even though we may not like it at all. Mental poverty is more serious problem than physical poverty and wealth poverty.*

Author Kumar: *Yes, but I believe that*

'Menlal poverty...physical poverty and wealth poverty' -all are interlinked.

Shyam Sunder Tiwari: *India Government was keeping its people under wealth poverty for several decades. In Germany those have no car or computer, Government gifts them. In India, some states gifted TV and other items only during elections and from stolen wealth but not under any serious understanding of the need of the people. All people have basic rights to survive. Extra-ordinary abilities*

can be appreciated or rewarded but those who are without must not be subjected to insults of not being special.

160. ONLY 'A FEW' GET RECOGNITION THANKS TO THE ADVERSARIES.

Shyam Sunder Tiwari: *When Rama and Rawana are recognized for their act in Ramayana, Sita and Lakshmana get sidelined even though they are one of the best characters in themselves. Moral of the story can accommodate only one Hero and one Villain at best even though lot*

many play their great role in the happening. Other than Jesus who do you think was a character of importance in the Bible? There are very many good people all the time who sustain the society and carry the flag of good will to humanity in all times.

161. ONLY 'REMINISCENCES' WILL BEAR THE TESTIMONY OF YOUR EXISTENCE.

Manju Ailawadhi: To be etched in someone's memory forever would be no mean achievement, isnt it?

Author Kumar: Yes, that is true.

145

Shyam Sunder Tiwari: *As per Stephen*

Haw king's philosophy, everything exists forever in time, and we only travel in time to see things in increasing time as they do already exist at sometime somewhere. We have no way yet known to go back in time. We do know that people existed before us, and all of them must be having love for life, and their life must be full of some story and yet they hardly make any sense to us other than those very few who created history that of

God or believers loving and serving God or being some kind of Devils that were eliminated by some God. Rest of the people is just fillers of space like wild animals who live and die in time.

162. UPHILL IS THE JOURNEY WITH THE ONE NOT DOWN TO EARTH.

· Manju Ailawadhi: *Yes until u see eye to eye wth the one, it definitely bcomz an uphill struggle.*

Shyam Sunder Tiwari: *It is always your own journey you need to worry about, whether it is uphill or down the*

drain.

163. ALIKE TWO SIDES OF A COIN, BOTH MIND AND HEART TOO, SPEAK DIFFERENTLY.

Manju Ailawadhi: *Absolutely true. Heart is in most cases at a tangent from the mind for the heart doesn't think, it just acts intuitively, and maximum times the heart is right. This is my perception of things; others are welcome to their point of view.*

164. IT IS THE FORMER GENERATION THAT ASCERTAINS 'THE SURGE OF INSTABILITIES' DURING THEIRS, DO NOT CREEP INTO THE LATTER ONES.

Manju Ailawadhi: *Surely, and a v big*

responsibility it happens to b.

Author Kumar: *But only to see that they become more insecure than earlier.*

165. CLOSE ASSOCIATIONS THINK FAR.

Manju Ailawadhi: *Those that are closely associated with you are the only ones who will think about your future probable's I believe.*

Author Kumar: *Not yours but theirs.*

Shyam Sunder Tiwari: *Person is most closely associated one's own brain. Working in team also requires individual skills and contribution*

from all. While it is good to be a team, anyone lazy in the team very likely to be disrespected by other team members. Usually, teams are like pillars to support a larger structures, and our Governments are also supposed to be like that for the people who helped them to reach where they are but exactly what they do there finally matters.

166. SOME FIND FIRST IN EVERY LOVE BUT DO NOT GET EVEN THE LAST.

Manju Ailawadhi: *It is really not an easy job getting the love one dreams of, for*

dreams remain dreams and by their very nature most remain unrequited.

Author Kumar: *Yes, but I believe that the non fruition of dreams only fall to one and not the other would be/ or associated to.*

167. NO GREATER GIFT THAN OF 'HAPPINESS IN LIFE' CAN EVER BE, AND THE TRUTH MAY BETTER UNDERSTOOD FROM THOSE WHO TRY ADDING IT FURTHER BY TAKING SOME OF THE OTHERS.

Manju Ailawadhi: *Taking anything is far easier than giving, whatever it might b, whether peace or any material thing.*

Author Kumar: *very rightly said.*

168. IN REAL LIFE GAME TOO, IT IS THE OPPONENT THAT KEEP YOU ON YOUR TOES THROUGHOUT.

Manju Ailawadhi: *Yes, for an 'opponent', the very term signifies unreliability, and that necessititates being on one's toes. But nevertheless 'being on one's toes' keeps one fitter, agile and alert too. That also means your ' opponent cannot catch u 'off guard' or napping.*

Author Kumar: *Yes, at least this positive aspect is of course there.*

169. SOME ARE ABLE TO SURVIVE ONLY DUE TO THE 'FITTEST'.

Manju Ailawadhi: *Eventually life is really a game where the fittest survives, now whether it is by hook or by crook no one, I repeat no one in today scenario seems to mind it. Only reaching the destination whether by means that are foul or fair is the ultimate motive...*

Author Kumar: *Very acute and correct.*

Shyam Sunder Tiwari: *True. The one who survives the worst environment is called the fittest for the niche.*

170. SWEET REMEMBRANCES KEEP YOU GOING.

Manju Ailawadhi: *Yes Sanjeev. Memories do give pleasure. Even though when things are happening and they may not be as sweet but once over memory adds a gloss to it. And in instances where things were excellent memory makes them doubly sweeter. That is what life is all about.*

Shyam Sunder Tiwari: *Sweet remembrances do not give us going. They do make us happy. Our experiences of all kind become our knowledge which let us*

keep going in an intelligent way to gain new skills.

Author Kumar: *Yes very right Manju ji and Shyam Sunder ji alike in William Wordsworth's "Tintern Abbey" memories do work food for future years.*

171. ONLY AN 'IMMORAL' CAN DO DERELICTION OF DUTY AND YET CALL FOR CO-OPERATION.

Manju Ailawadhi: *Those who tom-tom morality from d rooftops r the furthest from it. At least that is my experience.*

Shyam Sunder Tiwari: *Fear of Consequences.*

Author Kumar: *for being identified.*

172. A CHILD IN YOU NEVER DIES.

Manju Ailawadhi: *That death is forced by outside agencies.*

Shyam Sunder Tiwari: *Did you mean that a child never matures? As long as there are so many births, love and fun will be around, and death is not necessary but is essential to keep the balance of life.*

Shyam Sunder Tiwari: *There is clear difference between expression of love with children at the level of their*

understanding and being vigilant at the same time to protect them. Once matured, you can't go down in your childhood other than remembering and recalling....

Shyam Sunder Tiwari: *You are what you are, and only knowledge and body look changes.*

Author Kumar: *Very true.*

Tripti Tyagi: *Utmost true. However on a clause that one remains innocent and morally high as ever.*

173. ONLY A FEW TAKE BIRTH TO SAFEGUARD OTHERS.

Manju Ailawadhi: *All r not born either to b protective or helpful. Some r individually sent in dies world to do good to humanity, but sadly a larger chunk is v self-centered n unconcerned with what might befall others*

Author Kumar: *Yes, very truly said.*

174. THE SEEDS THAT BEAR THORNS LIVE VERY LONG.

Manju Ailawadhi: *For they have no danger of shriveling.*

Shyam Sunder Tiwari: *Live with Armor and defend yourself.*

175. UNSOUGHT INCLUSION ONLY CUT YOU TO SIZE.

Manju Ailawadhi: *One has to tread softly n b only where one is wanted.*

Tripti Tyagi: *Truly said however it makes only simulacra.*

Shyam Sunder Tiwari: *Your size is independent of what others may do. History has so many examples where great people never got their due. Whether Jesus was cut to size? He*

became bigger in time.

Author Kumar: *Very very true.*

176. IT IS THE 'NATURE' THAT COUNTERPOISES ALL.

Tripti Tyagi: *When it is maltreated by men, it can react tyrannically as well.*

Shyam Sunder Tiwari: *Survive or parish is only two options.*

Author Kumar: *Yes.*

177. THE DEFINITION OF 'TRUE LOVE' DIFFERS FROM PERSON TO PERSON.

Manju Ailawadhi: *Yes but it has to have*

the recipient's interest at heart.

Manju Ailawadhi: *I believe courtship right is given to a deserving person and yes not too many. And when one is concerned about the loved one it should be reciprocated in equal measure, for if d feeling is not mutual it may be infatuation only.*

Shyam Sunder Tiwari: *All gestures are momentarily conceived, and some may last for decades in adjustment of "give and take" relationship. Truth may have both sides of the coins as it*

is not something fix but a quantum mechanically generated thought wave in the human mind.

Shyam Sunder Tiwari: Love is a dynamic state of mind.

Manju Ailawadhi: Yes love n affection seek an answer, for each one of us, feel d warmth of love and wish to be reassured that we are really in love with a worthy one, for without love life is only 'existing' n not 'living.'

Author Kumar: I feel happy and indebted to the members for entrusting the

group and further enriching all of us with their different perspectives which we otherwise remain ignorant of. Thank you all.

178. THE ONE WITH A FIXATION FOR 'CLEANLINESS' IS A MISFIT BEYOND DOUBT.

Shyam Sunder Tiwari: *It is a psychological reflection.*

Author Kumar: *Yes, no doubt.*

Manju Ailawadhi: *Excess of everything is bad, whatever form it may be in.*

179. ONLY PARENTS CAN BE TAKEN FOR

Manju Ailawadhi: *Yes, though at some*

point of time we realise it is not the done thing.

Shyam Sunder Tiwari: *Parents invite children to this world of misery, so they have much greater responsibility also. Children have no option but to live in this complicated world of survival and then finally die.*

Author Kumar: *greater responsibility' including the one mentioned above within frame.*

Shyam Sunder Tiwari: *Many countries have laws against bad parents and*

we also need these in India as there are many bad parents and children can't take them for granted to be responsibly good to them. However, it should be the way you said, but it is not in the real world.

Author Kumar: *Good irony.*

180. 'WEAK' FEEL STRONG FOR THEY HAVE EXCESSIVE FAITH IN THE WEIGHT, A PAPER CARRY.

Manju Ailawadhi: *Such a delusion.*

Author Kumar: *Yes. What a personal belief some live in.*

181. MAY BE THE ONE, WHO NEVER COULD EXPRESS, WAS YOUR TRUE LOVE.

Manju Ailawadhi: *Times have changed drastically; this is true of yester years.*

Author Kumar: *May be it is true.*

182. IT IS BETTER TO SHED THE IDEA OF A 'JOINT UNIT' IF EVERY DWELLER BEING TO STIPULATE 'SPACE.'

Shyam Sunder Tiwari: *Everyone requires some space to remain comfortable, and its encroachment is often considered very offensive.*

Author Kumar: *Good Afternoon Shyam Sunder ji. Yes, very true as you said*

'some', but if turns out to be 'all,' then I believe you will agree to the notion of leaving the idea of a joint unit altogether.

Manju Ailawadhi: *Some is ok, but at each n every moment if it is done then d v concept of joint venture gets devastated.*

183. THOSE WHO HURRY INITIALLY TO ENTER THE SUBSEQUENT AGE, OFTEN LAND THE LAST AFORETIME.

Shyam Sunder Tiwari: *The time you had is your knowledge and the time you may have is only an expectation.*

Manju Ailawadhi: *Hurrying whither n with what expectation?*

Author Kumar: *That is what has never been understood by any including the ones in question.*

184. THE UPBRINGING OF OFFSPRINGS BECOME A GREATER UPHILL TASK RELATIVELY, ESPECIALLY WHEN BOTH THE PARENTS ARE BROUGHT UP UNDER DIFFERENT SCHOOLS OF THOUGHT.

Manju Ailawadhi: *U mean to say there is a constant tug of war between d patents on matters of upbringing?*

Author Kumar: *I believe the difference of opinion does matter.*

185. NO GREATER CRUELTY CAN EVER BE THAN THE ONE WHEN YOU DO NOT GET WHAT YOU DESERVE BUT EVERY TIME GIVEN THE IMPRESSION THAT IT IS UNDERWAY, AND SOON WILL BE YOURS.

Manju Ailawadhi: *Yes definitely, to keep stringing along people n feeding them false hopes is cruelty of d highest order.*

186. IT IS NOT EMPTY BUT SCHEMING MIND THAT IS DEVIL'S WORKSHOP.

Manju Ailawadhi: *Yes a schemester who is merely wasting his energy in plotting n planning all d time; though it may fetch some returns to begin with but in the final reckoning it all boils*

down to a zero.

187. IDIOTIC NATURE IS HEREDITARY.

Manju Ailawadhi: *U mean a fool's offspring will definitely take after him?*

Author Kumar: *No the offspring will inherit them.*

Shyam Sunder Tiwari: *It is not a disease.*

Author Kumar: *No not at all.*

188. MOMMA'S BOY CAN NEVER BE OF OTHERS.

Manju Ailawadhi: *Is that so? I believe some can balance their lives quite*

admirably.

Author Kumar: *I don't think so.*

Shyam Sunder Tiwari: *Till he finds another mamma of his age to play.*

189. AND THEREFORE, A BLABBERMOUTH AND THE POLAR IS AN IDEAL DUO, FOR THEY DO NOT SUPPRESS ANYTHING FROM EACH OTHER.

Manju Ailawadhi: *'Thick as thieves' aren't they?*

190. A CHATTERBOX HAS NOTHING TO HIDE.

Manju Ailawadhi: *Becoz he/she has spilled all d beans.*

Author Kumar: *Yes, because he has*

something to say everytime and when one run short, he starts spilling the same from the heart

Shyam Sunder Tiwari: *He who is conscious of what he knows also knows exactly what he says.*

Author Kumar: *True enough.*

191. THE WORTH OF ALL IS UNDERSTOOD IF ATTAINMENTS ARE SECURED AFTER THOROUGH AND A DUE STRUGGLE.

Manju Ailawadhi: *He who has toiled can really enjoy d fruits of his labor; else the sheen gets soiled.*

Author Kumar: *Yes very right.*

192. UNDERSERVED DISHES MAKE THE PERSON MOST INCAPABLE /UNSUITED TO ALL.

Manju Ailawadhi: *When undeserved gets a 'dish' he hardly knows it's worth.*

Author Kumar: *Yes and if at any point of time one realizes its value the same is snatched.*

193. NO 'CELLBLOCK' CAN BE SCARIER THAN YOUR DWELLING PLACE IF EVERY INMATE IS AN OFFICER IN HIMSELF.

Manju Ailawadhi: *In today times all r officers and none is a soldier.*

Author Kumar: *very rightly said.*

173

194. IT IS A MATTER OF GRAVE CONCERN AND NOT COMFORT, FOR THE INDIVIDUALS STANDING AT YOUR BACK, ARE NOT FOR YOUR SUPPORT BUT HAD MADE, <u>YOU</u> THEIR GUARD.

Author Kumar: *Exactly. I agree what you say for it is the human tendency in general since times immemorial, and nfortunately, one realizes it very late that those who posed as the committed supporters throughout, minus a few, were the only ones who backed out in testing times.*

Manju Ailawadhi: *Those that stand behind r not always supporters but*

seekers of self-advancement, n therefore in testing times they r d first to abandon d ship.

195. SWINGING OF MOOD MORE OFTEN IS A RARITY BEYOND DOUBT.

Manju Ailawadhi: *Whiter it might b, but it think it makes a person unreliable.*

196. BE ON YOUR TOES, MAINLY WHEN A CUNNING OLD DEVIL REVIVES FROM A STATE OF COMA, FOR THEN, HE IS ALL SET TO COMPLETE HIS REMAINING MALICIOUS BLUEPRINTS, AND THAT TOO, WITHOUT EVEN WAITING FOR THE RIGHT TIME.

Manju Ailawadhi: *And your readiness wil tilt the scales in your favour.*

Author Kumar: *Not exactly, but certainly*

can escape the disfavor that may come to you for being in the range

197. A DEADLY BEAST IS UNPREDICTABLE IF RESCUED PRETERM.

Manju Ailawadhi: 'A dangerous 'beast' will always b unpredictable whether rescued 'preterm' or otherwise; for a beast is always a beast.

Author Kumar: True but become more deadly in this case.

198. THOSE WHO OFTEN INQUIRE OF THEIR RATING ON ETHICAL VALUES, IN FACT, ARE STILL NOT CLEAN.

Manju Ailawadhi: Since the questioning is

there I think it in itself explanatory.

Author Kumar: *...provided the one answer is awaited from is not an idiot.*

199. IT IS ALWAYS THE NEXT GENERATION THAT TELL THE GAPS YOU NEED TO FILL UP.

Manju Ailawadhi: *That is true for child is father of man; besides when one view things objectively they appear in a clearer perspective.*

Author Kumar: *May be it is a better option for there is not any other available if one really wants to survive without further bone of*

contentions from any specially the younger ones.

R.K.Chadha: And we all know how futile it is to try even to bridge the gap. The more we try to close the gap wider it becomes.

200. NEVER LET ANYONE KNOWS THAT YOU HAVE A HEART FOR 'SOME' MAY DICE WITH YOUR FEELINGS.

Shyam Sunder Tiwari: Unless you speak it out, others won't know about your love feelings and all great feelings may go in waste as they are only waves in time and will die down on their own.

Author Kumar: *Good Evening Shyam Sunder ji. Long time no see. How are you?*

Manju Ailawadhi: *Deepest feelings are sometimes best undisclosed.*

Author Kumar: *Very true and explicit.*

Manju Ailawadhi: *Honestly that does happen, once it is public knowledge then that heart is not only diced but grated and pounded too for some are sure that there won't be any retaliation.*

> ## 201. AND THE BEST AWARD FOR 'SELF MOCKERY' GOES TO-ANY GUESSTIMATE-YES, YOU ARE RIGHT-THE ONLY AND ONE WHO HAD OUTLIVED HIS LIFE BY GIVING EVERYBODY AN OPPORTUNITY TO ENABLE EACH FOR MAKING HIM 'FOOT' AGAIN THE AGAIN.

Manju Ailawadhi: *Yes for hadn't Shakespeare written ' the fault dear Brutus lies in our stars that we r underlings.'*

Author Kumar: *when you prick us do we not bleed.*

> ## 202. ONLY 'ROGUISH' TAKE HIS SHELTER FOR A 'HIDEOUT'.

Manju Ailawadhi: *The very devil is quite*

adept al quoting scriptures for his purpose.

Author Kumar: and poor innocent blind superstitious followers take him to be real and consider they to be the chosen ones to have been standing behind him.

Manju Ailawadhi: But I believe they can't 'have been standing behind him' without some vested interest/carrot in return for services rendered.

Author Kumar: Yes, very true for it is both who are out to help that way each

other though, unconsciously?

203. ALIKE BREATH 'UNCOMFORTABILITY WITH ANY, ALSO IS SHORT-LIVED.

Manju Ailawadhi: *When incompatibility may change into compatibility n vice versa one never knows.*

Author Kumar: *But I was thinking in terms of 'breath' and thanks to its short life one also gets freed of this uncomfortability soon.*

204. AN ILLIBERAL IS AT ITS WORST ESPECIALLY TOWARDS HIS END.

Manju Ailawadhi: *There is no merit in having negative traits.*

205. BEHAVIORAL SCIENCE IS THE ONLY SCIENCE THAT TEACHES YOU TO LEARN THROUGH REAL EXPERIENCES.

Rakesh Tyagi: *Sir, if our eyes and ears are open, and we have willingness to learn, we learn a lot from day to day experience.*

Kavita Tyagi: *Sir, very acute and precise observation.*

206. ONLY THE 'GOOD' CARRIES THE FINAL VERDICT.

Manju Ailawadhi: *Yes, beyond any doubt.*

Rakesh Tyagi: *Sir, I fully agree with you. I have seen it many times that if you*

are good from inside, God takes care of you & you need not worry for anything.

207. IT IS THE OCCUPANT AND NOT 'CHAIR' THAT CHANGE.

Manju Ailawadhi: *Occupants come n go, but the chair remains rooted firmly; n woe to d occupant who takes it to b permanent.*

Author Kumar: *Very true.*

208. SOME INTROSPECT ONLY IN RETROSPECTIVE TERMS.

Manju Ailawadhi: *Food for thought.*

Author Kumar: *alike in Tintern Abbey.*

Manju Ailawadhi: *Bcoz things dawn on them in retrospect.*

209. DISPARITY AMONGST SOME CAN NEVER BE AT PAR.

Manju Ailawadhi: *V v true.*

Author Kumar: *only because they are born great.*

210. 'INCOMPATIBILITY' IN THE BEGINNING LASTS TILL THE END.

Manju Ailawadhi: *Sometimes it is like 'first impression is d last impression' if one is not compatible to begin with it never comes.*

Author Kumar: *Very true.*

211. SOME ALWAYS GRUMBLE THAT THEY DID NOT GET WHAT THEY DESERVED BUT NEVER ENDORSE THE UNDERSERVED.

Manju Ailawadhi: *That happens bcoz we excel at living in ivory towers n magnify our capabilities manifold.*

Author Kumar: *and also enjoy Icarus fall one day.*

Manju Ailawadhi: *Undoubtedly.*

212. EACH GIVES THE BEST WHEN COME IN A GROUP OF THREE ALIKE IN MACBETH.

Manju Ailawadhi: *'When shall we three meet again, in thunder, lightning and in rain...' there is an ominous*

digit.

Author Kumar: *Yes and then they can bring thunder and lightning in the life of the one whosoever come in their way.*

213. ONE SHOULD IGNORE/ AVOID THE SHOW IF THE 'TRAILER' IS NOT WORTHY.

Manju Ailawadhi: *Yes, it should b discontinued with immediate effect.*

214. ONE WRONG DECISION FOR NOT RECOGNIZING THE BEST SUITABLE LIFE LONG COMPANION DELIBERATELY JUST BECAUSE OF THE MYTH THAT IT IS FOUND ONLY AFTER A THROUGH SEARCH, FORCE YOU ULTIMATELY TO LIVE ALL ALONE, FOR YOU GET THE SAME TREATMENT BY THE LATTER, ONE DAY.

Manju Ailawadhi: *Yes Sanjeev all of us have to bear d yoke of our choice (?) made willingly or under duress of some agency. But once done it bcumz irrevocable.*

Author Kumar: *Very true.*

Author Kumar: *This is what many reach to the conclusion but again whether they are right this time may remain a mystery for nobody has been bestowed with such longevity.*

Shyam Sunder Tiwari: *Life is experimenting, and learning and*

partnership is no different. If you join Army, then start loving bullets as well. Why to expect someone to be good to you? Only try to be good to someone.

215. OH, GOD! LIBERATE US FROM THOSE WHO ONLY EXCEL IN MAKING ONE FALL IN THEIR 'MOUSE TRAP' AGAIN AND AGAIN.

Manju Ailawadhi: *Isn't it such an irony that simpl peopl fall in d 'mouse trap' of d crafty onez again n again, n then d only way out is tu seek divine intervention for 'liberation'.*

Author Kumar: *Because only HE can liberate them, for the ones who excel*

in the nature being talked about are just cannot be labeled as 'humans' whom any person can think have even dare to.

216. ONE CAN BE DEVOTED ONLY TO "ONE".

Shyam Sunder Tiwari: *"One" has many meanings, oneself, individual self, individual other, and only one person in the entire world. Devoted means in service of someone. Devoted does not mean dedicated. It sounds like slavery to me. Freedom of mind and thoughts and choice in Life is excellent for all. Free your Soul from*

ull kinds of slavery including devotion.

Author Kumar: *True, because commitment to me too, somewhere stops one to dedicate himself to any of his duty or else wise*

Shyam Sunder Tiwari: *Devotion is for the faith or belief or trust for which you do things. You devote life to many things and not just "one".*

Author Kumar: *Yes, but I have never been able to digest so as to why still many and that too in 'cyber age' only rely*

on their devotion and believe that now onwards no requirement is left at all to dedicate themselves to their worldly duties.

Shyam Sunder Tiwari: *Our search is always inside while we all seek things from outside in the world. Inside is only knowledge and outside is the materialistic word. Cyber world is utter confusion of everything, and you must be getting tired of it for sure. My search is always inside me.*

Manju Ailawadhi: *True devotion can b to*

one only n that too smacks of a kind of slavery.

Author Kumar: *and therefore, needless to repeat what had been said in epics and at different times as well that it is 'work is Worship" but unfortunately even today many read it vice-versa*

Shyam Sunder Tiwari: *Not all work is worship else the Devil's work will also be his kind of worship.*

217. AVOID 'SOME' WHO INVARIABLY NEED ONE TO THE PASTIME.

Manju Ailawadhi: *Pastimers shud b*

avoided like d v pestilence.

Author Kumar: *Yes.*

218. THE 'SCARIEST' HAD BEEN THE ONES WHO ENTERED SAYING THAT THEY CAME TO YOU AND MAKE IT A 'BLESSING' WHEREAS, IT WAS NEVER THEIR INTENT.

Manju Ailawadhi: *For they 'wore a face to meet the face 'that they met.*

Shyam Sunder Tiwari: *Desires bring people close to each other's and when desires re not fulfilled then they become a cause of sorrow.*

219. 'TRUST' CAN YIELD IMPECCABLE RESULTS.

Shyam Sunder Tiwari: *Trust is always to be*

betrayed.

Author Kumar: *I differ, for it never always betray, provided the intent both ways is unquestionable but certainly many a times that I agree with you Shyam Sunder ji . Yes, no doubt it does*

Manju Ailawadhi: *I think betrayal is always despicable.*

220. THE ONLY COMPANY THAT FRIGHTENS YOU THE MOST IS THE ONE WHOM YOU ARE DIRECTLY ATTACHED TO.

Shyam Sunder Tiwari: *I always walk with my two invisible friends, the death,*

and my karma. - Adi Sankaracharya.

**221. NO GREATER SYMPATHY CAN DRAW
TOWARD THE ONES WHO FALL VERY EASY
TO THE PREY BY REVEALING THEIR DEEPEST
HIDDEN SECRETS AFTER THEY ARE
PAMPERED AND TO BE OUSTED FROM THEIR
HEARTS SOON AFTER.**

Manju Ailawadhi: *Sometimes the
predators cum in d guise of friend's n
unwittingly simple people reveal their
innermost secrets.*

Author Kumar: *and that do not deserve
absolvement at all*

Manju Ailawadhi: *Yes bcoz what is
ethically wrong is wrong. This is*

again betrayal of trust that u mentioned earlier.

222. WE PREFER TO LIVE DESPITE ALL ODDS, ONLY TO SEE THE END AND THE SUSPENSE ATTACHED TO EVERY STORY WE HAD BEEN A PART OF, AS WE WILL REMAIN BLISSFULLY IGNORANT OF THE SAME, OTHERWISE.

Shyam Sunder Tiwari: *We are born, wasn't our choice that we do live is our choice.*

223. EACH DAY THE WORLD AROUND TAUGHT A NEW LESSON AND EVERY TIME I FORGOT-COULD NEVER BECOME A GOOD STUDENT.

Manju Ailawadhi: *And that is the reason that people like u n me r jostled*

around n taken as weaklings.

Author Kumar: *very rightly said.*

224. PLAY SAFE FOR BOTH THE SENIORITY AND HEADSHIP ARE SHORT LIVED.

Manju Ailawadhi: *But some revel in it thinking 'they can sing n dance forever on a day' but feel depressed later.*

225. THE PRIME OBJECTIVE IS IRRECOVERABLE IF THE MAIDEN DISCUSSION OPENS UP INTO NEW AVENUES AND SCOPE FOR THE BATTLE OF WORDS.

Manju Ailawadhi: *And battle of words cant b won so quickly esp. from u sirji.*

Author Kumar: *nahi nahi aisa to bikul*

198

bhi nahi .I totally disagree on this count at least.

226. 'COMMUNION' CAN BREATHE ONLY BETWEEN THE ONE'S PROMISED.

Manju Ailawadhi: *Else it wouldn't b 'Communion'.*

Author Kumar: *True enough.*

Tripti Tyagi: *Ideally that can be held only with wordsworthian nature that lacks today in every aspect.*

227. THE WEIGHT THE SWORD OF DAMOCLES CARRY, IS SO HEAVY THAT THE ONE ON WHOM IT IS HANGING, DIE MANY A TIMES BEFORE IT ULTIMATELY KILLS, IRRESPECTIVE OF THE SINCERE EFFORTS ONE PUTS IN TO ESCAPE THE ENGULFED DEADLY VIRUS ON IT.

Manju Ailawadhi: *And d Damocles sword doesn't spare even d biggest conniver, contriver, manipulator, ET all. And long b4 it falls on dat head 'the person dies many a times b4 his death'.*

228. TO PERCEIVE WHAT THE OTHER HAD CONCEALED UNDERNEATH THE FEATHERS IS A COMPLETE VENTURE OF ITSELF.

Manju Ailawadhi: *Bcoz some r pastmasters*

at d arl of concealing n feigning.

Tripti Tyagi: *It is an expedition to the land which we can never actually explore.*

229. EVEN THE 'MIGHTIEST' FALL, SIMPLY BECAUSE THEY WERE NEVER ANY, BUT MADE TO BELIEVE THE MYTH BY THE WEAKEST.

Manju Ailawadhi: *Turn d pages of history n u will find that even grt rulers who had d 'misconception' of their grtness got brutally crushed. It is 'poetic justice' n as I have always held justice is meted out to d 'pretended mighty' ones too.*

Author Kumar: *Very true.*

230. TEARS ARE SHED TO GENERATE FEAR, BUT THE FACT IS THAT IT IS THE FEAR THAT POURS IN TEARS.

Manju Ailawadhi: *Tears are an expression of pain n fear provided they r not crocodile tears.*

Author Kumar: *But tears that are shed to generate fear simply can never be an expression of pain.*

231. ONE MAY WIN, PROVIDED IN THE NEXT HALF OF THE BATTLE THE SUPPORTERS FAIL TO UNDERSTAND THAT THEY ARE BEING MADE THE 'SCAPEGOATS' AGAIN.

Manju Ailawadhi: *Only if d poor*

'scapegoats' r able to read between d lines.

232. WE LOVE ONLY 'THE PEOPLE WITH CONSTRUCTIVE NATURE' THOUGH THEY WORK LESS-MAXIMUM UP TO 18 HRS BUT NEVER TO THE ONES WITH 'DESTRUCTIVE MINDSET' DESPITE THEIR WORKING UP TO ALMOST 48 HRS OR BEYOND IN A DAY.

Manju Ailawadhi: *Your today thought is surely going to energies the work shirkers n giving them an elevated opinion of themselves!*

Author Kumar: *Very rightly said, Mam. We love people for 'what they r at the core' and their being protagonist or antagonist at heart doesn't matter at*

all.

233. THE MOST ACTIVE YOUR OPPONENTS ARE WHEN THEY ARE PASSIVE.

Manju Ailawadhi: *Yes bacon we get fooled thinking them r sleeping.*

Author Kumar: *Yes. The fact is they never sleep.*

Manju Ailawadhi: *Whn we imagine there iz a lull, in fact, there is greatr activity in progres. For they that hav tu stamp on peoplz head forsake their own sleep first. 'It iz the bright day (not the rainy one as imagined) that*

brings forth the adder, and that craves vary walking... said the great Bard.

Author Kumar: *Very well said.*

234. EVEN IF WE COULD REDUCE THE NUMBER BY ONE OR TWO WHO WOULD BID YOU BYE FROM THEIR CORE OF HEART ON YOUR LAST DESTINATION, THAT WILL BE AN ACHIEVEMENT.

Manju Ailawadhi: *And a genuinely rare achievement.*

235. SELF STYLED 'KINGMAKERS' CAN ONLY MAKE EVEN KINGS- A PAUPER.

Manju Ailawadhi: *'Kingmakers' r also king breakers r'nt dey?*

236. SWEET REMEMBERENCES KEEP YOU GOING.

Rakesh Tyagi: *Yes sir, sweet memories are our assets. We are recharged by remembering them.*

Manju Ailawadhi: *Sweet memories/ remembrances delight us time and again, it, therefore, becomes imperative that we consciously work towards hoarding good memories as fixed deposits!!*

237. A 'UNION' THAT BELIEVE ONLY IN 'TRADE' JUST CANNOT BE CALLED A TRADE UNION.

Manju Ailawadhi: *Yes bcoz they mostly*

understand the term 'barter' n use it to perfection. They no longer protect any genuine interests.

Author Kumar: and this 'barter' they do it very genuinely.

238. 'MASTER-STROKE' BY THE OPPONENTS DESERVES APPRECIATION, BUT THE COMPLIMENTS SHOULD NOT MAKE THEM PRESUMPTUOUS, FOR THE GAME HAS NOT COME TO AN END YET.

Manju Ailawadhi: The game doesn't end that fast. Only the batsman bcums d bowler n then playz a better inningz.

239. THE ENACTMENT OF A ROLE BECOME MORE CHALLENGING WHEN THE ROLE OF A 'SCHEMER' IS PLAYED BY A FAILURE 'OTHERWISE'.

Chandra Shekhar Dubey: *Kya bat hai? The road of excess leads to palace of wisdom.*

Manju Ailawadhi: *Sir maina toh bahut din pehle hi Sanjeev ko 'sage' keh diya tha.*

Author Kumar: *Had run out of options except to scribble*

Chandra Shekhar Dubey: *Better, much better for health. 'Rites of passage.'*

240. 'IDIOTS' HAVE ONE POSITIVE TRAIT-THEY ARE ADVENTUROUS ENOUGH AND CAN AFFORD TO MUDDLE WITH THE BEE HIVE ONLY FOR A LIVELY CLICK.

Manju Ailawadhi: *Wonderful. Your lines convey a world of meaning.*

241. YOU NEVER LISTENED TO, FOR THEY TAKE YOU ALWAYS FOR GRANTED, EITHER OUT OF EXCESSIVE CONFIDENCE OR NOT AN IOTA OF IT AT ALL.

Manju Ailawadhi: *So a win win position eh? U hav turnd into a true philosopher.*

242. THE MORE YOU LEAVE EXPRESSIONS OF 'INNOCENCE', THE MORE YOU GET THE BENEFIT OF THE DOUBT!

Author Kumar: *Yes. Not all can be real*

hypocrites, but majority do/can utilize smile emoticon this skill of theirs as it doesn't need any training as such.

Author Kumar: Even a layman can do it with perfection.

Manju Ailawadhi: Ek chehre pey kai chehre laga letay hain aur innocent ka mukhota pehan kar jahan ko fool kartey hain.

243. TV AND DEVOTION 'WITHIN' A DWELLING UNIT ARE AMPLE TO RUIN THE PEACE AND HARMONY IRRESPECTIVE OF ALL.

Manju Ailawadhi: Mera chaain sab loota?

244. THE CHOICE FOR NOT BEEN ABLE TO LIVE CAN SIMPLY BE NEVER YOURS.

Manju Ailawadhi: *Yes birth n death r not in our preview.*

245. GOALS REMAIN VERY UNCLEAR PARTICULARLY WHERE 'WORSHIP' ATTRACTS ABSOLUTE ATTENTION.

Manju Ailawadhi: *So designated 'bhagvan'/aaka ko khush karne ke liye 'worship' toh karna padega.*

246. EVEN THOSE WHO LIVE ROUND THE CLOCK WITH THE SPECIES OF 'SNAKES' DO NOT TRUST THEM FOR THEY KNOW THAT SO CALLED MASTERS TOO, WILL NOT BE SPARED ONE DAY.

Manju Ailawadhi: *True enough.*

247. THE SHIP IS BOUND TO WRECK ESPECIALLY WHEN EVERY PASSENGER STARTS TAKING HIMSELF TO BE THE CAPTAIN OF THE EXPEDITION.

Manju Ailawadhi: *Too many masters start differing v fast.*

248. NEVER BLAME ANYBODY FOR THEY NEVER HAD ANY ROLE IN YOUR SHARE OF HAPPINESS AS IT WAS FOREORDAINED.

Manju Ailawadhi: *And therefore d loss is theirz, not yours. Only lucky onez can share anyonrz hap.*

Author Kumar: *The pleasure is exclusively mine.*

249. FEAR LESS THE ENEMIES THAN TO YOUR FRIENDS.

Manju Ailawadhi: *Friends or those who pose as friends n well-wishers.*

250. BE EXTRA CAREFUL WITH THE ONE, WHO ALWAYS SMILES.

Manju Ailawadhi: *'For they that smile have millions of mischief hid in their hearts isn't it.*

Author Kumar: *Yes exactly.*

251. SUSTAINED MAGISTERIAL NATURE CAN ONLY GENERATE IRREVERSIBLE 'HATE'.

Manju Ailawadhi: *Naturally.*

R.K.Chadha: *Very appropriate one liner which shows the bitter truth that*

being too judgmental damages mutual relations permanently.

252. OUR PLACEMENT IN EITHER OF THE WORLD ABOVE WILL SOLELY DEPEND ON THE TYPE OF CERTIFICATE AND DEGREE, THE INSTITUTION CALLED 'SOCIETY' WE LIVE IN CONFER ON US. WE MAY GET THE HINT IF SO DESIRED. AT THE LAST PLATFORM, JUST LOOK BACK AND SEE HOW MANY HAVE COME TO SEE YOU OFF.

Manju Ailawadhi: *All who cum to see off at d final journey do not cum either for love or respect alone. Some also*

cum out of duress of that very society; tu create an impression of their being pious n good souls n who sincerely care for all.

Author Kumar: *Very true, but to me, those who come out of duress also more or less means the same thing for the person who had left was important enough to have stimulated them exclusively because of his importance in terms of the deeds or else wise and hence, was pious and a good soul.*

253. EYES THAT BRING TEARS IN NO TIME FOR SEEKING FAVOR CAN ONLY BE OF MASTER HYPOCRITES WHO OFTEN PRETEND WEAK/'ULTRA SENSITIVE' AND BRING EACH FALL OF THEIR TANTRUMS QUITE COMFORTABLY.

Manju Ailawadhi: *I too have been a victim of such tantrums though vicariously,*

Sanjeev.

Author Kumar: *Oh so sad.*

Manju Ailawadhi: *No no not sad. U know about it n also d one who became d medium of that.*

254. TIME LEAVE RUST ON EMOTIONAL BONDINGS, TOO.

Manju Ailawadhi: *But it becomes our duty to dust away d rust.*

255. IT IS NOT ONLY THE 'PRESENT' BUT THE 'PAST' THAT DETERMINES THE 'PRESENT' AS WELL AS OUR 'FUTURE.'

Manju Ailawadhi: *All our actions have a reaction sooner or later. When v*

indulge in an excess v feel happy to put d other down, but when v become d recipient of our actions v cringe n howl.

Manju Ailawadhi: *Yes bcoz sometimes guided by emotions v do act wrongly though unknowingly. It is only when d action boomerangs v realize our judgement wz erronous.*

Author Kumar: *No comments because we all still wait for those who' indulge in an excess...(and) feel happy' as unfortunately in some cases we see*

that even 'your well-wisher(s)' do not 'tie the hand(s)'.

Author Kumar: *the wait also includes so as to when will them ultimately' cringe n howl'.*

256. IT IS ONLY THE EVIL THAT CONTINUES TO LIVE IN SOME, FOR THEY KILL GOOD-SELF-ALIAS ESTEEM MUCH BEFORE.

Manju Ailawadhi: *Sure enough they kill their esteem on their journey towards evil, n r then destroyed by dat same evil.*

257. "EXCESS" CAN GENERATE ONLY ACCESS OF 'HATE.'

Tripti Tyagi: *Nice maxim.*

258. "PAST" TO 'SOME' NEVER BECOMES PAST.

Rakesh Tyagi: *I agree, we should forget our past, do' not worry about future and enjoy the present but we generally do opposite to all these three.*

Manju Ailawadhi: *Yes for some 'past' never becomes past, for they firmly hold it and do not wish to let it go. With some, it's hard but still others have an ulterior motive, and that is bad, for once one gets an occasion to*

smoothen out the past it should be accepted willingly.

Author Kumar: *True. Words like 'Ancient' and 'glorious' always go hand in hand.*

Vasant Sharma *Living in The Present I believe that only one person in a thousand knows the trick of really living in the present. Most of us spend 59 minutes of every hour residing in the past, with regrets for lost joys, shame for things badly done (both utterly useless and weakening) - or in*

a future which we either long for or dread. Yet the past is gone beyond prayer and every minute spent in the vain effort to anticipate the future is a moment lost forever. There is only one world, the world pressing against you this minute. There is only one minute - here and NOW. There is only way to live by accepting each minute as an unrepeatable miracle. Which in exactly what it is - a miracle and unrepeatable. Storm Jameson

259. DO GOOD BUT ALSO, PRAY THAT IT DOES NOT BOOMERANG THE OPPOSITE.

Rakesh Tyagi: *Sometimes we are bieng backfired by opposite even if we do good . That is the time we feel helpless, and we repent on our nature for few seconds.*

Manju Ailawadhi: *Despite doing good, it does sometimes get channelized into just the opposite of what one intended.*

Printed in the United States
By Bookmasters